DRAWING ON THE DOMINANT EYE

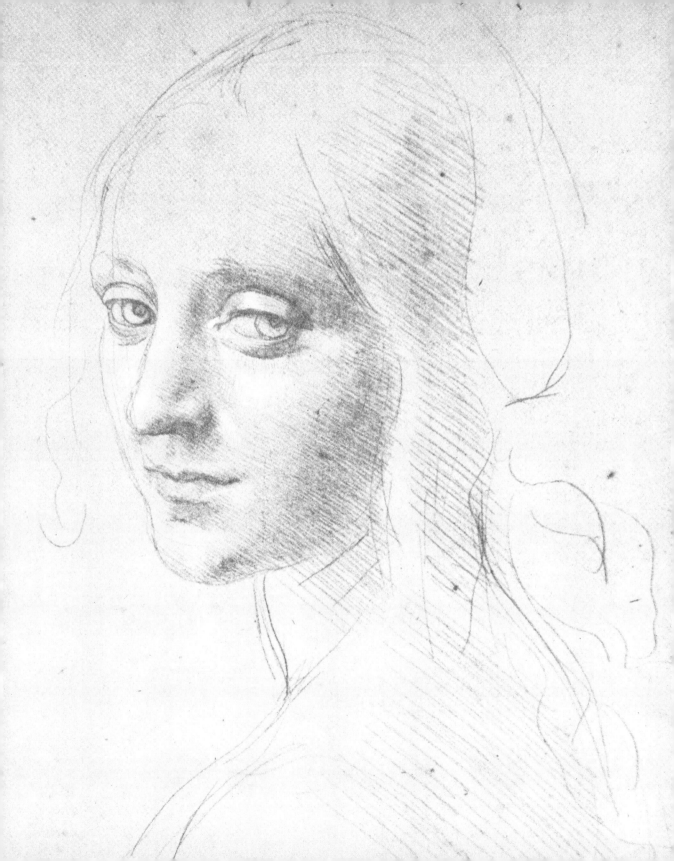

DRAWING ON THE DOMINANT EYE

Decoding the Way We Perceive, Create, and Learn

Betty Edwards

A TarcherPerigee Book

Leonardo da Vinci, Study for the Head of a Girl *(detail).*
Silverpoint with white highlights on prepared paper, 181 x 159 mm.
Biblioteca Reale, Torino.

an imprint of Penguin Random House LLC
penguinrandomhouse.com

Images pages ii, xiv, 2, 3, 13, 18, 19 (bottom), 35 (top right, bottom right), 37 (bottom), 45 (bottom), 48, 70, 71, 74, 80 (bottom), 84, 88 (bottom), 93 (top right, bottom right), 96, 97, 99, 101, 102, 120, 127, 128, 130, 131, 140 courtesy Alamy.com
Image page 19 (top) courtesy of Marc Dingman via neuroscientificallychallenged.com
Hieroglyphics image page 75 courtesy vexels.com
Image page 76 courtesy vectorstock.com
Images on pages 78, 82 (right) courtesy Shutterstock.com
Photo pages 85, 93 (top left) courtesy Getty Images

TarcherPerigee with tp colophon is a registered trademark of Penguin Random House LLC

Most TarcherPerigee books are available at special quantity discounts for bulk purchase for sales promotions, premiums, fund-raising, and educational needs. Special books or book excerpts also can be created to fit specific needs. For details, write: SpecialMarkets@penguinrandomhouse.com.

Library of Congress Cataloging-in-Publication Data
Names: Edwards, Betty, 1926–
Title: Drawing on the dominant eye: decoding the way we perceive, create, and learn / Betty Edwards.
Description: [New York]: TarcherPerigee, [2020]
Identifiers: LCCN 2020032920 (print) | LCCN 2020032921 (ebook) | ISBN 9780593329641 (hardcover) | ISBN 9780593329641 (ebook)
Subjects: LCSH: Human information processing. | Ocular dominance—Problems, exercises, etc. | Drawing—Psychological aspects.
Classification: LCC BF444 .E39 2020 (print) | LCC BF444 (ebook) | DDC 153.7/58—dc23
LC record available at https://lccn.loc.gov/2020032920
LC ebook record available at https://lccn.loc.gov/2020032921
p. cm.

Printed in the United States of America

1 3 5 7 9 10 8 6 4 2

Book design by Shannon Nicole Plunkett

I dedicate this book
with love
to my daughter and son,
Anne and Brian

ACKNOWLEDGMENTS

First and foremost, I am grateful beyond words for the invaluable assistance and guidance over many years of Robert Barnett and Deneen Howell, partners at Williams & Connolly LLP, in Washington, DC. From the initial proposal to the publication of my book, their help was essential, and it continued step-by-step through the entire process. To both, a heartfelt thank-you!

I'm also grateful to Megan Newman, vice president and publisher of TarcherPerigee of Penguin Random House, for her skillful oversight of the project, and to Marian Lizzi, editor-in-chief and vice president, for her careful reading and probing questions about my manuscript. Marian is a writer's ideal editor: rapid responses, tough queries, and a delightful sense of humor. To Megan and Marian, thank you!

To the TarcherPerigee design staff, especially associate art director and jacket designer Nellys Liang and book designer Shannon Nicole Plunkett, thank you! The entire editorial, design, and marketing team has been a delight to work with, including Farin Schlussel, Anne Kosmoski, Alex Casement, Lindsay Gordon, Andrea Molitor, and Victoria Adamo. I'm especially grateful to Rachel Ayotte, editorial assistant, who kept everything focused and on track. To the whole team, my thanks!

To my daughter, Anne Bomeisler Farrell; my son, Brian Bomeisler; and my son-in-law, John Farrell: my family contributed greatly to this project, to my benefit. My daughter, Anne, is an excellent writer, reader, editor, and soundboard for ideas. She has exceptional technical skills and was enormously helpful in making sure that each iteration of the manuscript remained safe, updated, and accessible. Thank you, Annie!

My son Brian's superb drawing skills were put to good use in many of the book's illustrative drawings, and the before-and-after drawings were the result of his inspired teaching of the methods of *Drawing on the Right Side of the Brain*, which he has been doing for many years. He also helped greatly with reviewing the manuscript. Thank you, Bri!

My son-in-law, John Farrell, a history professor and himself a fine writer, was yet another invaluable manuscript reader and editor. Thank you, John!

As always, I am inspired by my granddaughters, Sophie and Francesca, both of them the lights of my life.

My dear friend, Amita Molloy, who recently retired as a book designer for the J. Paul Getty Museum, generously put her formidable expertise toward helping me understand some important design principles that appear in the final cover. Thank you, Amita! And to her late husband, Joe Molloy, the esteemed graphic designer in Los Angeles, whose beautiful design of *Drawing on the Right Side of the Brain* was a touchstone for the look of this new book, I offer my enduring gratitude.

I feel honor-bound to once more express my appreciation to the Venice High School students and the thousands of our Drawing on the Right Side of the Brain students around the world who, over the years, have contributed so greatly to my understanding of how a person learns to draw. Thank you to all our students!

And finally, I express my gratitude, as always, to the memory of neurobiologist and Nobel Laureate Dr. Roger W. Sperry, for his generosity and kindness to me so many years ago.

<div align="right">

—Betty Edwards

August 2020

</div>

A NOTE ABOUT THE COVER SELF-PORTRAIT

About five decades ago, I drew the self-portrait that is on the cover of this book. I have kept the drawing all these years as a sort of memento of a significant life change—from a life as an aspiring artist to a recognition of my need for a steady job and income to support my family—that classic crunch when reality sets in, something that may be familiar to anyone who aims for a life as an artist.

I opted to become a teacher, eventually in a full-time job as an art teacher at Venice High School, a public school in West Los Angeles. Eventually, I pursued a master's degree and then a doctorate at UCLA, all the while teaching art and gaining more understanding about the brain and its powerful role in creativity and learning to draw. About ten years later, those experiences led to my book *Drawing on the Right Side of the Brain*, and to a new and far more public career.

Now, looking back over a long life, this self-portrait, drawn many years ago, like all such drawings, retains its place for me as a life-marker but also fortuitously works here as a clear illustration of a dominant (in my case) right eye.

CONTENTS

DRAWING ON THE DOMINANT EYE

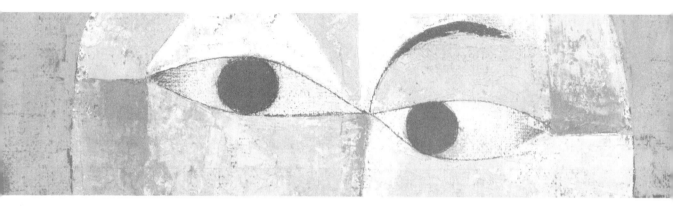

Paul Klee, Senecio or Head of a Man Going Senile, *1922.*
Kunstmuseum Basel, Basel.

Introduction

Curiosity about other people is a powerful human trait. We want to know: Who are they, really? What are they thinking? What are they feeling? To catch a glimpse of the "real person" behind the words and appearance of people we meet, we have always had two main tactics. One is listening closely to spoken words. The other is trying with our eyes to "see into" the mind and thoughts of the real person as reflected in their face and eyes.

Over the centuries, writers and thinkers have generated countless proverbs and quotations about this somewhat subconscious search. Roman statesman Marcus Tullius Cicero (106–43 BC) said, "The face is the portrait of the mind, with the eyes as its interpreter." Roman Catholic priest, theologian, and historian Saint Jerome (AD 347–419) said, "The face is the mirror of the mind, and the eyes without speaking confess the secrets of the heart." A Latin proverb, date unknown, states, "The face is the portrait of the mind, the eyes its informer."

Even Yogi Berra (1925–2015), American professional baseball catcher, chimed in, "You can observe a lot by just watching."

One of the best-known quotations, origin unknown, is: "The eyes are the windows to the soul," telling us that by looking deeply into someone's eyes we can find the hidden "real person."

Marcus Tullius Cicero,
106 BC–43 BC

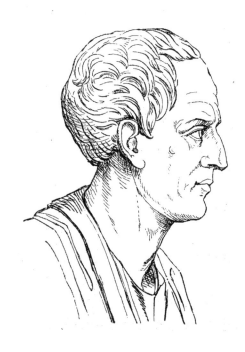

A more modern (but less poetic) version might be, "The dominant and subdominant eyes reveal the mind." But then questions arise: Which eye are we talking about, left or right or both? And which mind, since there are actually two "minds," the left and right hemispheres of the brain? And why are the eyes designated differently, "dominant" and "subdominant," since they seem to most of us to be pretty much the same? In fact, our two eyes are visibly different, one from the other, reflecting our two minds and our two ways of viewing the world. That difference between our two eyes is observable and, at the same time,

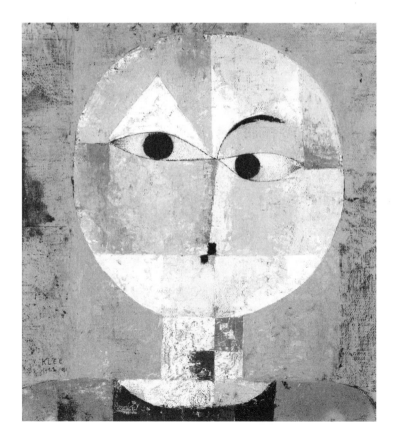

Swiss-born German artist Paul Klee (1879–1940) said, "One eye sees, the other feels."

Paul Klee, Senecio or Head of a Man Going Senile, *1922. Kunstmuseum Basel, Basel.*

strangely unrecognized. Might the difference be helpful in our search for "real" persons?

At a conscious level, we know that what we see with our eyes is intimately connected to what we think and how we think and, at the same time, what and how we feel. Oddly, we seem to be unaware that when we look closely enough in a mirror into our own eyes, or look into other people's eyes face-to-face, we can actually *see* which eye is reacting to the words we are speaking or hearing and which eye may be *feeling* but not attending to the words. Most people are unaware of this difference. But again, we use this information subconsciously in our daily lives, most notably to guide our interactions with other people.

Those interactions are complicated by the so-called crossover connections of mind/brain/body. For most of us, our left-brain hemisphere "crosses over" to control the right side of our bodies, from head to toe, including the function of our right-dominant eye. Likewise, our right-brain hemisphere "crosses over" to control our left side, from head to toe, including the function of our left subdominant eye.

The right eye, then, is most strongly connected to the verbal brain half, which (for most people) is the left hemisphere. In both casual *and* important face-to-face conversations, each of us subconsciously seeks to connect with the other person's dominant, verbally connected right eye. We seem to want to speak right eye to right eye—dominant eye to dominant eye.

In face-to-face conversations, we often subconsciously avoid the other eye, the subdominant left eye. It is mainly controlled by the nonverbal right-brain hemisphere and is visibly more disconnected and unresponsive to spoken words. Nevertheless, it is there, looking a bit remote, as though dreaming, but in fact reacting to the tone, the tenor, and the more visual and emotional, nonverbal aspects of the conversation.

My personal awareness of this strange visual difference in our eyes has come about over many years, as a result of both teaching and demonstrating portrait drawing in our Drawing on the Right Side of the Brain workshops. The more I have observed, the more it has intrigued me. Thus, this book examines how all of us "draw" on the dominant eye.

André Dutertre (1753–1842), Portrait of Leonardo da Vinci, in the collection of the Royal Academy of Arts, London. © Photo: Royal Academy of Arts, London. Photographer: Prudence Cuming Associates Limited.

Two Ways of Seeing and Thinking

People sometimes ask me how I got into the art field. It started very early for me. My mother was an unusually visual person who occasionally did a bit of drawing. An important influence on me as a child was not only her drawing ability but also her delight in seeing things. On an outdoor walk, for example, she would suddenly exclaim, "Oh, look how those tiny daisies have arranged themselves in the grass!" or "Oh, look how that shadow changes the color of that house!" These remarks, though always prefaced by "Oh, look . . . ," were really not meant to elicit a response from me. But on seeing her delight, I would try to see for myself what had caused it. I think that this unintended call-and-response in childhood had an enormous effect on me, and perhaps was the basis for my later interest in the whole process of drawing one's perceptions.

Then, in fourth grade, my teacher was Miss Brown (we called her "Brownie" behind her back), and we adored her. The school was a public elementary school in a working-class neighborhood of Long Beach, California. Looking back, I see how amazing Miss Brown was. The fourth-grade subject for the year was astronomy. In her classroom, we built an actual planetarium (a cardboard tower about six feet across) and punched out holes in the domed top for the constellations of Perseus, Andromeda, Orion, and the Pleiades. Furthermore, we studied the Greek and Roman gods and molded bas-relief sculptures of them using thick, cooked cornstarch as the sculpture medium

with which we formed the gods on bases of scrap lumber. Mine was of a kneeling Atlas holding up the world on his shoulders. Miss Brown read the Greek myths aloud to us while we worked on our sculptures.

These rich early-childhood experiences seem to be gone forever from modern education. They are too dangerous, too messy, and they cannot be scored using standardized tests. But why couldn't small bits of them be revived? Surely, for example, we could manage a bit of drawing in our modern classrooms.

Later in life, during long years of my own education up through a doctoral degree, I was able to experiment with that idea when I started my teaching career at Venice High School in West Los Angeles. The students there joined me in the most delightful way in trying to figure out why it seemed so difficult to learn to draw what is right in front of your own eyes.

The result of that teaching experience, and also of the wide publication and popularization of Roger Sperry's groundbreaking work on brain-hemisphere functions, was *Drawing on the Right Side of the Brain*, first published in 1979 and revised three times in my effort to keep up with ongoing educational research. It is still in print today around the world and has helped millions of people learn to draw and to access their innate creativity.

During the decades after the book was published, my teaching colleagues and I developed and taught an intensive drawing workshop based on *Drawing on the Right Side*

of the Brain. The workshop consolidates the methods I developed into five days of basic drawing lessons. The result is that we can successfully teach individuals (with or without art experience) to gain access to their visual, nonverbal right-brain hemispheres and to learn the essential basic perceptual skills that enable people to draw what they see. These basic skills, five in number, are:

1. **The perception of edges (where one thing ends and another begins)**
2. **The perception of spaces (negative spaces)**
3. **The perception of relationships (proportion and perspective)**
4. **The perception of lights and shadows (creating the illusion of three dimensions)**
5. **The perception of the whole (the gestalt)**

These *seeing* skills, largely processed in the visual, perceptual right-brain hemisphere, are comparable to the basic language skills of reading (surprisingly also five in number), which are largely located in the other half of the brain, the left-brain hemisphere. For learning how to read, the basic language skills, as defined not by me but by reading-instruction experts, are:

1. **Phonics (understanding that the alphabet letters represent sounds)**
2. **Phonetics (sounding out words from letter sounds)**
3. **Vocabulary (learning what the words mean)**

4. Fluency (being able to read quickly and smoothly)[1]

5. Comprehension (understanding the meaning of what is read)

In my view, these are twin sets of skills, one set for drawing and one for reading, located more or less separately in the twin hemispheres of the brain. I believe they should be taught with equal enthusiasm in our public schools. Unfortunately, they are not.

Public schools today remain singularly focused on left-brain language-based skills—in fact, they are increasingly concentrated in this way as time goes by, with the emphasis on science, technology, engineering, and math—disciplines collectively known as STEM. Parents seem to have accepted this one-sided emphasis partly because they may be unaware of the importance of visual skills for thinking, learning, and problem solving, as well as for reading. Perhaps this parental concern is based partly on unfounded fears that their children might become overly enamored of the arts, which are not supported by our modern American culture, and thus will end up as "starving artists."

To develop a complete mind:
Study the science of art;
Study the art of science.
Learn how to see.
Realize that everything connects
to everything else.

Leonardo da Vinci (1452–1519)

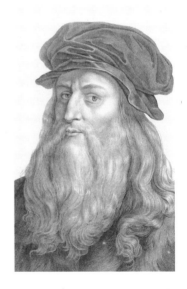

André Dutertre (1753–1842), Portrait of Leonardo da Vinci, in the collection of the Royal Academy of Arts, London. © Photo: Royal Academy of Arts, London. Photographer: Prudence Cuming Associates Limited.

[1] I have always objected to reading experts' listing of fluency as a basic skill. I believe fluency is an outcome of learning to read, not a basic skill. Furthermore, what is omitted in this list is syntax—the way in which sentences are constructed with a subject/verb/object.

Despite (or perhaps because of) this singular focus on verbal skills, two out of three American fourth- and eighth-grade children are losing ground in reading. The Nation's Report Card, from the National Assessment of Educational Progress, or the NAEP test, in 2019 reported the dismal results that only 35 percent of fourth graders and only 34 percent of eighth graders are proficient in reading, with both groups' scores *down* from the 2017 assessment. One educational reporter asked, "Why are we getting dumber?"

"Reading Scores on National Exam Decline in Half the States," Erica L. Green and Dana Goldstein, The New York Times, *October 30, 2019; "Reading and Math Scores in U.S. Are Falling. Why Are We Getting Dumber?," Luis Miguel,* The New American, *November 2, 2019.*

Because both sets of skills, verbal and perceptual, are in fact essential to all fields of endeavor, it is important to point out that we do not teach left-brain language skills solely to produce poets and authors of books but instead to enable learning and thinking in all fields. In the same way, we should teach right-brain perceptual skills through the arts *not solely to produce artists* but instead to enable optimal learning, problem solving, and thinking in all fields.

Imagine if there were not this existing singular focus on language and language-related "left-brain" skills, and if we also taught visual perceptual skills through drawing, painting, music, sculpture, dance, and other arts-related right-brain skills as well as visual imaging of processes and outcomes. Our children would gain the advantage of learning how to envision the complete picture, to apprehend both the forest *and* the trees, and to comprehend the whole and not just the fragmented parts. Albert Einstein put it perfectly when he said, "It is a miracle that curiosity survives formal education."

Additionally, I believe that teaching arts-related skills to achieve whole-brain development requires serious, substantive subject matter for study, not the more usual fun-time, pseudo-creative arts activities currently still practiced in most of the few remaining art classes. The main reason for these lightweight art activities is that many art teachers, having come up in the same school system that does not teach drawing, cannot themselves

draw and therefore cannot teach drawing, just as teachers who cannot read would not be able to teach their students how to read.

Therefore, in our five-day Drawing on the Right Side of the Brain workshops (for adults who in childhood learned to read but never learned to draw), we do not draw easy subject matter. Instead, we take our cues from earlier times. In the late nineteenth and early twentieth centuries, basic reading texts did not use dumbed-down "see-and-say" or boring "Dick and Jane" reading material.

Childhood textbooks once included serious poetry, passages from the Bible, and weighty essays on subjects like proper behavior. Echoing the logic of those early-childhood reading texts, in terms of teaching drawing our reasoning has been, "As an adult, if you are going to learn to draw, and since every drawing of a seen subject requires the same five basic skills, you might as well begin with interesting and challenging subjects that are worth the effort."

Therefore, our nondrawing adult students in our five-day workshops do not draw the easy subjects often seen in beginners' classes, such as a few blocks of wood, a bowl of oranges, or a simple vase of flowers.

In drawings of these subjects, if the perceptions are massively flawed, no one knows, and no one cares. Instead,

The fact that our Upper Paleolithic ancestors drew astonishingly beautiful and lifelike images of animals on cave walls thirty thousand years ago, long before written languages were invented, provides evidence of the importance of drawing for human development.

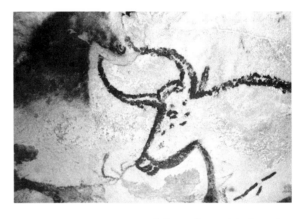

A Stone Age painted cow in a prehistoric cave near Lascaux, France, circa 40,000–10,000 BC

our students draw subjects traditionally considered to be among the most difficult but also the most rewarding: their own hand (perception of edges); a chair, seen at an angle (perception of negative spaces); a perspective view of a room (perception of relationships); a profile portrait of a fellow student (perception of lights and shadows); and on the last day, the most difficult subject of all: a full-face self-portrait (perception of the gestalt).

Because in order to portray the subject—these drawings force close and accurate perception of the whole *and* of the smallest details—you notice things that ordinarily may be unseen. In portrait drawing, and most especially in self-portrait drawing, one of the things you "see and draw" is the surprisingly common unseen difference between the two sides of the face.

In particular, very evident and almost always unseen at conscious level is the subtle but discernible difference

Left: Richard Honaker
Before instruction
July 9, 2018

Right: Richard Honaker
After instruction
July 13, 2018

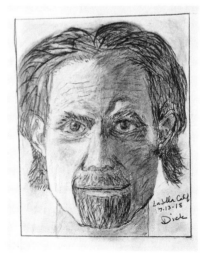

between the right eye and the left eye, as seen in the photo of Albert Einstein. The scientist was clearly right-eyed (right-eye dominant).

In contrast, George Bernard Shaw may have been left-eye dominant. The left eye appears more alert and engaged, while the right eye is more hidden by the eyelid, and the eyebrow over his right eye is almost like an arrow pointing to the left eye.

And that brings us back to the subject of this book: the dominant eye, the observable difference between the two eyes, and what that observable difference might mean in terms of differences in *seeing and thinking* as well as our outward and inward selves. As the French humanist photographer Henri Cartier-Bresson (1908–2004) said, "One eye looks within, the other eye looks without."

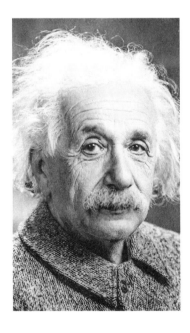 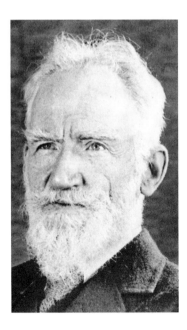

Left: Albert Einstein.
Photographer: Orren Jack Turner.

Right: George Bernard Shaw.
The National Archives of the Netherlands.

Vincent van Gogh (1853–1890), Self-Portrait (1889). National Gallery of Art, Washington, DC. Collection of Mr. and Mrs. John Hay Whitney.

The Dominant Eye and the Brain

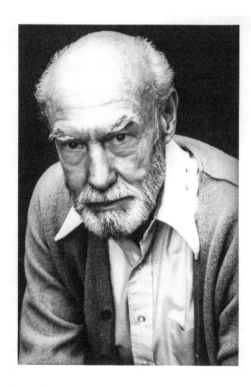

Roger Sperry

Since the 1960s, awareness of the different functions of our right- and left-brain hemispheres has become fairly well-known. The Nobel Prize–winning discoveries achieved by neuropsychologist/neurobiologist Roger Sperry and his colleagues at the California Institute of Technology during the late 1950s and early 1960s have been widely publicized, analyzed, criticized, honored, debated, and debunked, but the original findings have never been refuted.

For whatever reason, the human brain, along with the brains of other vertebrates on our planet, is divided into two hemispheres that constitute separate and different "minds" whose responses to inner and external reality are shared, deliberated, and reconciled by connections between the two hemispheres. Our right and left eyes are "windows" into this division of our minds.

Sperry's groundbreaking work, the so-called split-brain studies (1959–1968), revealed the unexpected and somewhat startling information that once a patient's two cerebral hemispheres were surgically disconnected from each other, it became apparent, through Sperry's innovative testing and experimentation, that each hemisphere had its own functions and preferences, separate from and different than its

cerebral partner. Each brain half was seemingly that of an individual person.

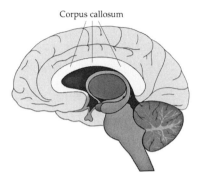

Corpus callosum

Sperry's split-brain studies were based on the experiences of epilepsy patients suffering from seizure attacks that passed from hemisphere to hemisphere through the corpus callosum, or large body of nerve fibers, the main linking connection between the hemispheres.

That thick band of nerve fibers is the major means by which the two hemispheres are connected, communicate, combine their two views, and agree—or, in some circumstances, disagree or perhaps refuse to communicate.

Once the main linking body and other minor connections were surgically severed, the patients' epileptic attacks were prevented from spreading from hemisphere to hemisphere and the patients' lives were much improved.

Tweedledum and Tweedledee could be regarded as Lewis Carroll's fanciful re-creation of the two brain hemispheres, always linked together by their entwined arms, always ready for a quarrel—or a battle. As Carroll says of them, "Mostly, they get along, but occasionally they 'agree to have a battle.' Tweedledum is the one most handy with words. 'We *must* have a bit of a fight, but I don't care about going on long,' said Tweedledum. 'What's the time now?' Tweedledee looked at his watch, and said, 'Half-past four.' 'Let's fight till six, and then have dinner,' said Tweedledum."

Lewis Carroll, Through the Looking-Glass *(1871). Tweedledum and Tweedledee illustration by John Tenniel.*

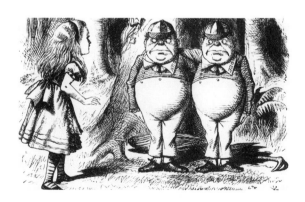

Following this quite extreme surgery, the patients' seizures were under better control and, gratifyingly and amazingly, they resumed their former lives and seemed outwardly restored to good health. Over time, however, Sperry's innovative tests of their thinking intriguingly and unexpectedly showed that each side of the patients' brains was now functioning as a separate "individual" with its own perceptions, concepts, impulses, and reactions to what was happening in the world around them.

Roger Sperry's and his colleagues' experiments were based on flashing separate and different images to the

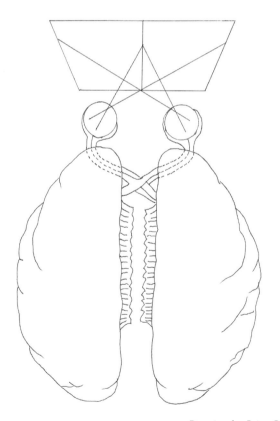

Drawing by Brian Bomeisler

right and left visual fields of his participants, a technique known as visual half-field presentation. Because each patient's corpus callosum had been severed, the information sent to each visual field could no longer be transmitted to the other hemisphere.

In one experiment, Sperry flashed the word "hammer" to a patient's right visual field, which was instantly sent only to the left, verbal hemisphere. When asked to name what was shown, the patient quickly responded, "Hammer." Then, when Sperry flashed a different word, "scissors," to the same patient's *left* visual field (sending the image to the *right* hemisphere), the patient could not articulate the word, but, using the left hand, the patient could draw a sketch of scissors.

The lengthy, detailed, and complicated research by Sperry and his colleagues during the 1950s and 1960s was awarded the Nobel Prize in 1981. Sperry had discovered that the left hemisphere of the brain was responsible for understanding, speaking, and writing language, while the right hemisphere could recognize some printed words but could not speak or write language. Significantly, however, the right hemisphere could produce drawings of objects named in print.[2]

Sperry's findings, broadly speaking, revealed that in our intact brains, we always have two thinking systems—

[2] Roger W. Sperry, "Hemisphere Deconnection and Unity in Conscious Awareness," *American Psychologist* 28 (1968), L 723–33, http://people.uncw.edu/Puente/sperry/sperrypapers/60s/135-1968.pdf.

something akin to having two individuals in our brains. One "person" is verbal, analytic, and sequential, mostly using language and logic to think and converse, usually preferring to take one step at a time (like words in a sentence) to carry out procedures and reach conclusions.

For most of us, this "self" is mainly located in the left hemisphere of our brain. In the other hemisphere is another "person," whose main mode of thinking is nonverbal (largely without words), visual, perceptual, and global, seeing and intuiting the whole all at once, perceiving how the parts fit together to make up the whole but also able to see each part as a "whole" and how *its* parts fit together, or, importantly, how the parts *are not* fitting together. This other "self" is mainly located in the right hemisphere of our brain. In our intact brains, because the corpus callosum provides instant and constant communication between these two "selves," we experience ourselves as one person, and the two "languages" meld into one.

But not quite.

Awareness of our two "selves" shows up in many ways, including what we say about ourselves. For example:

"I am of two minds about that."

"Part of me says yes, and part of me says no."

"On the one hand . . . , but on the other hand . . ."

Or my favorite: "Hey, wait a minute. What about . . . ?"

While this overall general structure applies to all human beings, individual brains can vary widely in their

The right hemisphere can recognize the meaning of some words and phrases but cannot use syntax (forming sentences using subject/verb/object), which is required for logical discourse and description. For example, "The boy hit the baseball." The nonverbal brain hemisphere might recognize and use the nouns "boy" and "baseball" but not the verb "hit," which forms the complete sentence.

organizational structure, and the effects of the differences show up in numerous outward signs.

"Handedness" is perhaps the most obvious of these variable signs. Right-handers make up about 90 percent of human beings worldwide and left-handers about 10 percent. Handedness shows itself by outward signs, most obviously in handwriting, but also in gesturing and handling of tools such as tableware, scissors, sports equipment, or carpentry tools. People are very aware of their handedness. If you ask, "Are you right- or left-handed?" the answer comes easily and without hesitation.

"Footedness," largely made visible by which foot is the one most often used to step forward first in walking, stair

Thankfully, the old practice of trying to force right-handedness on naturally left-handed children has been mostly eliminated from school and family practice.

Drawing by Betty Edwards

climbing, or dancing, is less well-known. On being asked, "Are you right- or left-footed?" many people are uncertain and will often stand up and try it out to see which feels like the dominant or leading foot. The exceptions are athletes and dancers, for whom knowing their dominant foot is useful information. Worldwide, about 60 percent of individuals are right-footed, 30 percent are left-footed, and 10 percent are equal-footed.

"Eyedness" is the least known and more variable of these outward signs of brain organization. About 65 percent of humans are right-eye dominant, and 34 percent left-eye dominant. For 1 percent, both eyes are equally dominant.

If you ask someone, "Are you right-eye dominant or left-eye dominant?" the most common answer is, "I don't know. How can you tell?" The exceptions are mainly portrait painters and photographers, who may be aware of eye differences through observation, and athletes, archery enthusiasts, and hunters, where *aiming* is a critical skill. The reason for the sports connection is revealed by the various tests for "eyedness" or "the dominant eye." You may be familiar with these tests.

TESTS FOR EYE DOMINANCE

One of the simplest is the following: Close one eye, fully extend an arm, and point with your index finger to some object across the room—the corner of a window, a doorknob, a light switch. Then, keeping your pointed finger on the same spot, change eyes. You will see that your pointed

finger is no longer on the target but is now widely off-target—off to the right of the target if you are right-eye dominant and off to the left if you are left-eye dominant.

The eye you kept open first is your dominant eye, and this simple test demonstrates the importance for sports people of knowing about eyedness. If you use the "wrong" eye to aim, you will miss, which is why athletes and sharpshooters are very aware of which eye is dominant.

Another Eye Dominance Test

1. Cut a hole in the center of a small piece of thick paper, such as a 3" x 5" index card. The hole should be about the size of a nickel or a dime.

2. Pick a distant object on which to focus, for example a light switch or the corner of a picture frame.

3. Hold the card in front of you with both hands at arm's length and view the selected target through the small opening. Take turns closing one eye, then the other. The eye that continues to see the target is your dominant eye.

A Third Test for Eye Dominance

1. Extend both hands forward and place them together to make a small triangular opening between your thumbs and the side of both hands of about ¾ inch to 1 inch.

2. With both eyes open, look through the triangle. Center on something across the room, such as a doorknob, the corner of a window, or a light switch.

3. Close your left eye. If the object remains in view, you are right-eye dominant. Test this by closing your right eye. You will see that your view has shifted sharply to the right and the target object is out of view. Open your right eye and reclose your left eye, and the object will again be centered in the small triangle. This means that you are right-eye dominant. If the opposite occurs, you are left-eye dominant.

TWO ADDITIONAL SIGNS OF BRAIN ORGANIZATION

Two additional but largely unknown signs of brain organization are as follows: When you clasp your hands, fingers entwined, which thumb is on top? Right thumb indicates left-brain dominance; left thumb, right-brain dominance.

And when you cross your arms, which arm is on top, right or left? Again, right arm on top indicates left-brain dominance and left arm on top indicates right-brain dominance.

These minor outward signs often contradict the main indicators of dominance, (handedness, footedness, and eyedness) and may be signs of minor so-called mixed dominance or what educational researchers have called "crossed laterality." For each of us, our brain is unique. Educators have looked for signs of learning difficulties related to mixed dominance, but the research to date does not support that assumption. Someday, we may know exactly what minor mixed dominance indicators mean, but not today.

I have described several simple and effective tests to determine which is your dominant eye, but eyedness is also observable simply by looking in the mirror or by closely observing another person's eyes, face-to-face. And here we encounter some very surprising aspects of the human face that we see . . . but do not see.

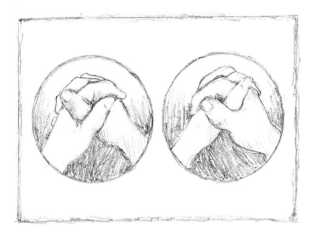

Which thumb is on top?

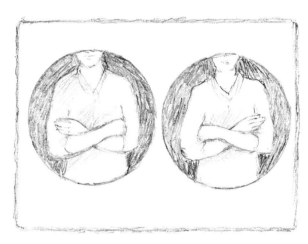

Which arm is on top?

Drawings by Betty Edwards

Rembrandt van Rijn, Self-Portrait in a Cap, Wide-eyed and Open-mouthed *(1630).*
Collection Rijksmuseum, Amsterdam.

Human Faces
and Expressions

We are all experts on human facial expressions. Research shows that even infants can detect changes in facial expressions. The tiniest change can signal an altered mood, and each of us seems to have a memorized catalog of expressions that helps us interpret the faces we encounter. During face-to-face conversations, both persons are aware of the other's whole face, and both are, of course, attending to the words spoken and hearing the tone of voice, but the main visual focus is on *eye-to-eye contact*, with the other facial features (eyebrows, forehead creases and wrinkles, mouth, etc.) playing a supporting role. Such an encounter may seem like an ordinary, everyday event, but in fact it is visually complicated.

One of the complications is that we generally think of human faces as symmetrical. We have two eyes arranged on either side of a center line that divides the eyebrows, the nose, and the mouth into a seemingly same-sided whole face. But when photographers divide a photo of a face and rearrange each of the face halves into two whole faces, we can see the slight but definite differences between one half of a face compared to the other half. As I have stated, scientists have determined that 65 percent of humans are right-eye dominant, 34 percent are left-eye dominant, and for 1 percent, neither eye (or both eyes) are dominant.

These mirrored face images show us what we would see if, in real-life conversations, it would be possible to focus

on just one side of a person's face and then on the other side and compare the two sides, one against the other. We don't do that; first, because it is difficult, and second, because we have little or no motivation to compare the two sides, other than a subconscious motivation to find and connect with the person's dominant eye.

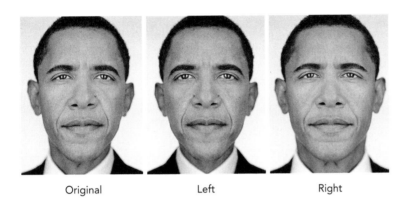

Original Left Right

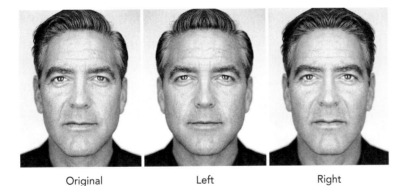

Original Left Right

Mirrored faces are photographs of human faces that have been cut in half vertically and reassembled as left-side only and right-side only—thus, mirrored images. The purpose is to show the sometimes-striking differences between the two sides of a single face.

For example, President Barack Obama is clearly left-eyed, along with 34 percent of the human population.

In these mirrored face examples of President Obama and George Clooney, the left image is the original, the middle image shows left symmetry, and the right image shows right symmetry. Both appear to be left-eye dominant.

Photos: Martin Schoeller / AUGUST

SEEKING THE DOMINANT EYE

We have often heard someone say, "He (or she) looked me straight in the eye and said . . ." This seems to be what we actually want when we are talking with someone

Some people avoid eye contact as much as possible, a syndrome known as eye contact anxiety. This may be caused by shyness or lack of confidence, or a person's fear that they might be negatively scrutinized or judged.

face-to-face—to be looked straight in the eye. But which eye? Subconsciously, for the 65 percent of us who are right-eye dominant, we want that person to visually connect to our dominant eye, the one that is more closely connected to the left-brain hemisphere, the brain half that can supply the right words to convey our ideas and contribute to the verbal content of the conversation. And for the 34 percent of us who are left-eye dominant, the same holds true. We hope that our conversation partner will connect with our left eye.

Whether we are left- or right-eyed, our conversation partner may or may not be aware of our other eye, the "subdominant" eye, more strongly connected to the nonverbal right hemisphere. The subdominant eye may be watching for expressive clues, intuiting the overall meaning of the encounter, attending to the other's visual body-language signals, facial expression, and tone of voice, but less able to relate to the spoken words—a sort of silent participant in the conversation.

One of the purposes of this book is to throw some light onto this somewhat unknown aspect of ordinary person-to-person encounters: the importance of looking someone "straight in the eye"—specifically, in the dominant eye. Determining which is the dominant eye requires a bit of knowledge of what to look for. That bit of knowledge can help us overcome our visual habit of automatically connecting to the eye of our conversation partner

that is the same as our own dominant eye. This habit is illustrated in the next section.

HABITS OF SEEING—OR NOT SEEING

While human faces are enormously significant to us, linking us to friends, family, and all the people who are important to us, over time we all develop certain habits of seeing—or not seeing—the faces we encounter.

One of the habits (particularly for the 65 percent of us who are right-eyed) is to simply engage automatically right eye to right eye. This habit is cleverly illustrated by author Terry Landau in the 1989 book *About Faces*.

Without willing it, right-handed, right-eyed people (the 65 percent of humans) focus automatically and strongly on the *left side* (right eye of both drawings, at right). They therefore see the top face as sad, troubled, or angry, and see the bottom face as happy, cheerful, and friendly. Even when you know that it is the same drawing, just reversed, it is very difficult to change that first impression, illustrating how strongly the *right-eye-to-right-eye focus* affects our response to a face.

If, of course, you are one of the 34 percent of humans who are left-eye dominant, the reverse is likely to be true. You will see the top face as cheerful, friendly, and happy, and the bottom face as sad, troubled, or angry.

If you are part of the 1 percent who have equal-eye dominance, the conjecture is that you will see neither

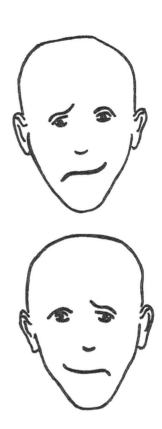

"Illustrations" from About Faces by Terry Landau, copyright © 1989 by Terry Landau. Used by permission of Anchor Books, an imprint of the Knopf Doubleday Publishing Group, a division of Penguin Random House LLC. All rights reserved.

eye as dominant and/or both faces as "interesting" or "hard to read."

There are consequences to this automatic tendency for eye contact. For the 65 percent of us who are right-eye dominant, eye contact is automatically dominant eye to dominant eye—right eye to right eye. The other eye, the "subdominant eye," is largely ignored, aware of the verbal conversation but not attending to the spoken words. Nevertheless, the other person's subdominant eye is there, watching for emotional clues, intuiting the overall *feeling* of the encounter, attending to facial expression (especially eye expression) and tone of voice.

If the nonverbal clues *match* the spoken words, or at least fit well enough with the spoken words, all goes well. If not, our conversation partner might later report, "Well, the words sounded okay, but there was something about the conversation that made me uncomfortable."

A consequence of our subconscious desire to connect dominant eye to dominant eye is that the 34 percent of us who are left-eye dominant must find ways to *persuade a right-eyed person to change* the automatic right-eye-to-right-eye response *to a right-eye-to-left-eye* focus. The 34 percent, therefore, may undertake a set of curious actions to *guide* our right-eyed conversation partners to our dominant eye. The simplest is just turning the head slightly, so that the dominant eye is *forward.* Another is lowering the eyebrow over the subdominant left eye, and *raising* the eyebrow over the dominant eye, as in this photograph

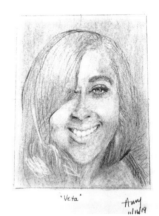

"Veta" Amy 11/16/19

A portrait of Veta by Amy Scowen Walsh, a Drawing on the Right Side of the Brain workshop student, was created in November 2019.

Dorothy Parker (1873–1967), legendary New York literary figure, journalist, and poet. She was known for her biting wit. Among her famous quotes: "Men seldom make passes at girls who wear glasses" and "The first thing I do in the morning is brush my teeth and sharpen my tongue." In the late 1910s, Parker worked for *Vogue* and *Vanity Fair*, then later as a book reviewer for the *New Yorker* magazine.

Photo by Vandamm Studio © Billy Rose Theatre Division, The New York Public Library for the Performing Arts.

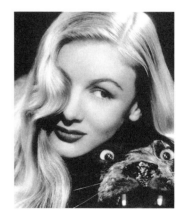

Veronica Lake (1922–1973), a movie actress best known for her work in the 1940s, famously popularized this hairdo, which fully covered her right eye.

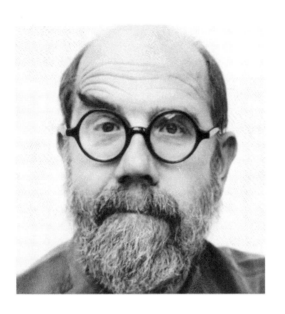

It would be hard to mistake which of artist Chuck Close's eyes is his dominant eye.

of artist Chuck Close, whose right eye is clearly dominant.

A more telling ploy is to hold one hand up to the face, partially covering the subdominant eye and forcing attention to the dominant eye.

Yet another ploy is to use eyeglasses, fortuitously very slightly angled lower over the subdominant eye to mask it and force the desired attention to the dominant eye.

Most drastic of all is a hairstyle that has come and gone over the past nearly hundred years and occasionally shows up today among female TV anchors and others. The hair is styled to literally *cover* the subdominant eye so that it is hidden from view—a nonsubtle way to force viewers to attend *only* to the dominant eye.

THE EYES AND "HUMAN SOCIAL SIGNALING"

The split-second assessment of Terry Landau's drawings (page 33) involved only two of literally hundreds, if not thousands, of possible facial expressions that we are decoding on a routine basis every day of our lives. Scientific research in this field (called "human social signaling") tells us that the eyes alone can convey countless variations of human facial expression. To simplify their investigations, researchers in 2017 narrowed their field

of study to just six basic categories of eye expressions: joy, fear, surprise, sadness, disgust, and anger.

In their report, the researchers noted that they were "surprised"[3] to find that all six of the basic eye-expression categories were largely expressed in only two ways: by either widening or narrowing the eyes. The researchers reported that the same two main expressions were originally described by the nineteenth-century evolutionist Charles Darwin in his iconic book *On the Origin of Species*, published in 1859. Darwin specified the two eye expressions as functional aids to human survival in prehistoric time: widened eyes (letting in more light and expanding the visual field) to enable seeing any large, lurking dangers such as dinosaurs or tigers; or narrowed eyes (reducing the field of vision) to better discriminate small hidden threats—snakes and spiders.

According to today's scientists, these two "all-purpose" eye expressions have now become the major and most frequent social signaling ploys: narrowed eyes expressing discrimination,

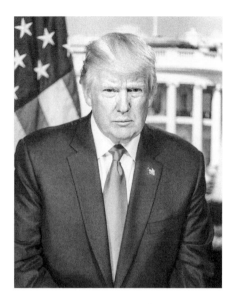

President Donald Trump's official White House portrait, courtesy of WhiteHouse.gov

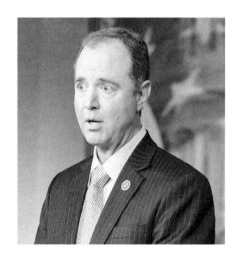

Representative Adam Schiff (D-Calif.) at a press conference in the US Capitol on Wednesday, March 22, 2017

[3] Daniel H. Lee and Adam K. Anderson, "Reading What the Mind Thinks From What the Eye Sees," *Psychological Science* 28, vol. 4 (2017): 494–503. The authors of the study used a term rarely found in scientific reports: "surprised." Research usually reveals incremental steps, not giant leaps.

suspicion, disgust, disapproval, puzzlement, and disdain; and widened eyes expressing surprise, sudden pleasure, shock, fear, anger, and joy. Unexpectedly, two major figures in today's politics epitomize these two main expression categories.

ARTISTS AND THE ART OF PORTRAYING HUMAN FACIAL EXPRESSIONS

Over the centuries, artists have been obsessed with human facial expressions and how to portray them. The success or failure of a work of art that includes human beings can often depend on that one aspect of a painting, drawing, or sculpture.

As everyone who has ever tried it knows, accurately portraying any of the countless human emotions by means of facial expression is incredibly, frustratingly difficult. With the slightest slip of the brush or pen or etching tool, a pleasant smile becomes a sarcastic grin. Anger becomes disgust. Tender regard becomes sadness or despair. And starting over is sometimes the only remedy. The Italian Renaissance artist Leon Battista Alberti (1404–1472) wrote in his 1450 instructions for artists, *On Painting*, "Who would ever believe who has not tried it how difficult it is to attempt to paint a laughing face, only to have it elude you so you make it more weeping than happy?"

Today, artists have photography and freeze-frame images to help them re-create subtle, fleeting human

expressions in works of art, but even now, the portrayal difficulties are still there. During the centuries before photography, artists had to rely solely on serious study, close observation, and technical skill. One of the artists best known for success in this endeavor is the Dutch artist Rembrandt van Rijn (1606–1669).

REMBRANDT AND SELF-PORTRAITURE

From his earliest years as an artist, Rembrandt was interested in self-portraiture, and he was among the first artists to concentrate on facial expression by using his own face to study the subject. In his midtwenties, Rembrandt embarked on a small series of self-portrait etchings that depicted his own face expressing widely different emotions. One can imagine the artist trying out expressions in a mirror, contorting his face to show surprise or shock, laughter, anger, puzzlement, or fear. The etchings that resulted were clearly exercises in portraying a variety of expressions and formed the start of Rembrandt's lifelong passion for self-portraiture and the portrayal of human emotions.

In Rembrandt's time, long before photography, artists had only mirrors as aids in self-portraiture. It is hard to imagine the difficulties Rembrandt faced in creating his series of self-portraits expressing emotions in one of the most challenging of all mediums, etching on a copper plate.

This complicated process begins with a thin copper

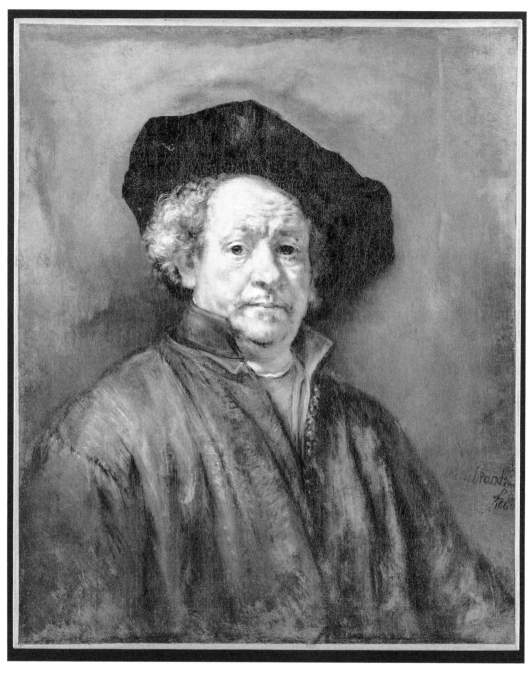

Rembrandt van Rijn (1606–1669), Self-Portrait (1660).
The Metropolitan Museum of Art, New York,
Bequest of Benjamin Altman, 1913.

plate covered with a thin coat of dark resin. The artist uses a pointed metal tool to scrape the lines of a drawing through the dried resin coating to reveal the copper beneath. When the drawing is complete, the artist applies acid to the plate, which etches (eats away) the copper exposed by the lines scratched through the resin. The acid forms grooves in the copper that will hold ink during printing. The remaining resin is then removed, and the plate is cleaned. Next, the artist dabs ink on the copper plate and wipes it to remove all the ink except for the ink embedded in the scratched-out, acid-enlarged grooves. The artist then covers the plate with a damp sheet of paper and runs it through a printing press to pick up the inked scratch marks of the drawing. Finally, the finished paper print with the inked image is pulled off the plate and hung on a line to dry. (See the illustration on the next page of the etching process.)

The potential pitfalls in this long and daunting process are profuse: etched lines may not be deep enough or may be too deep; the acid may be too strong and ruin the copper plate; too much ink is applied or too little ink; the ink may be too thick or too thin; the paper may be too wet or too dry—the potential problems are endless, and the artist can't know what issues might arise until the whole process is completed and errors show up in the printed image. Even then, the problems are not over. The printed image is a mirror image (a reversed image of the original drawing on the copper plate), inevitably magnifying

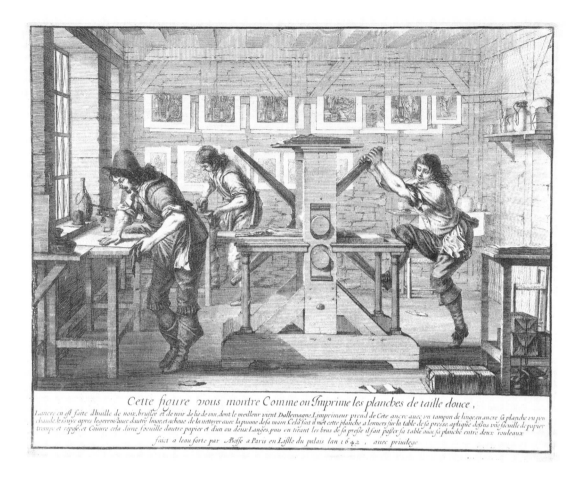

Cette figure vous montre Comme on Imprime les planches de taille douce,

Lancre en A faite d'huille de noix bruslee et de noir de lie de vin, dont le meilleur vient d'Allemagne, L'imprimeur prend de Cete ancre auec vn tampon de linge, en ancre sa planche vn peu chaude. les essuye apres legerem/auce d'autre linge, et acheue de la nettoyer auec la paume de sa main Cela fait il met cette planche a leuers sur la table de sa presse. aplique dessus vne feuille de papier tremps et repose. et Couure cela d'une feuille d'autre papier et d'un ou deux Langes, puis en tirant les bras de sa presse il fait passer sa table auce sa planche entre deux rouleaux

fait a l'eau forte par Bosse a Paris en L'isle du palais l'an 1642 , auec priuilege

Abraham Bosse (1602/1604–1676) The Intaglio Printers (1642). The Metropolitan Museum of Art.

any problems with the original drawing. Even signing the drawing on the copper plate is a problem. If the artist, without thinking, signs the plate with his normal signature, the signature will be reversed on the print, as happened a few times with Rembrandt's etchings.

To all these technical problems, add that Rembrandt was using his own face as his model and therefore had to repeatedly pose in a mirror with the desired facial expression (for example, eyes widened, head pulled back, mouth

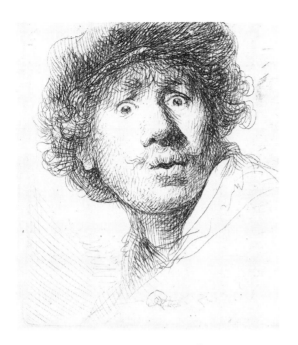

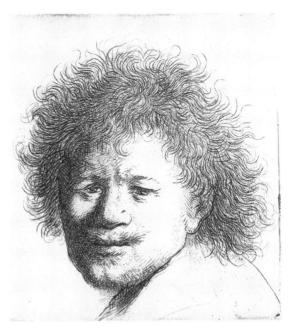

Rembrandt van Rijn, Self-Portrait in a Cap,
Wide-eyed and Open-mouthed *(1630).*
Collection Rijksmuseum, Amsterdam.

Rembrandt van Rijn, Self-Portrait with
Long Bushy Hair: Head Only *(c. 1631).*
Collection Rijksmuseum, Amsterdam.

pursed), study it, remember it, then turn to the resin-covered copper plate and reproduce that particular part of the expression using the pointed etching tool. Then, after turning again to the mirror, manipulating his face again into the desired expression, studying the image and memorizing it, he again goes back to work on the plate. And the process goes on and on. Rembrandt sometimes worked for several years on a single copper plate until he was satisfied with the prints (having cannily sold the various versions in the process).

As a result, we have this marvelous small set of etchings portraying human facial expressions by one of history's

Clifford Ackley, curator for more than forty years at the Museum of Fine Arts, Boston, and expert on Old Master prints and drawings, observed about Rembrandt's early etchings, "These quirky, personal, etched self-portraits are without precedent in the history of self-portraiture, particularly in print-making."

greatest artists. And among them are definitive images of the two major eye expressions singled out as broadly useful by many present-day researchers in the field of social signaling: widened eyes and narrowed eyes.

Self-Portrait in a Cap, Wide-eyed and Open-mouthed, dated 1630, is from Rembrandt's early self-portrait etchings, in which he used his own face to portray various facial expressions. According to our current scientists, the widened eyes in this etching could be expressing a huge range of emotions, from wonder or surprise to sudden fear, pleasure, anger, joy, incredulity, shock, or alarm. It is mind-boggling to learn that the copper plate on which Rembrandt etched this powerful image measures only 2" by 1½" (50 mm by 45 mm).

A second etching from the early series, titled *Self-Portrait with Long Bushy Hair,* is from about the same period (1631). It portrays the second of modern scientists' theory of two major eye expressions: narrowed eyes expressing disapproval, suspicion, puzzlement, or disdain, disappointment, despair, or countless other negative emotions. This etching is also tiny, about 3" by 2½" (64 mm by 60 mm).

It appears from these etched images that Rembrandt was right-eye dominant. The right eye is more open, looking directly at the viewer. The left eyebrow is pulled forward, and the crease above the left eyebrow almost forms an arrow pointing to the dominant right eye. The image on the copper plate, drawn from a mirror image,

would reverse Rembrandt's face, but the consequent paper print would re-reverse the image, indicating right-eye dominance, which later self-portraits appear to verify (see page 40).

Following Rembrandt's lead, artists across the centuries and around the world have recorded the effects of emotion on the human face, largely conveyed by the eyes. To this day, artists and photographers are inspired by the power of human faces to express emotions, especially the expressions of the eyes, the "windows of the soul."

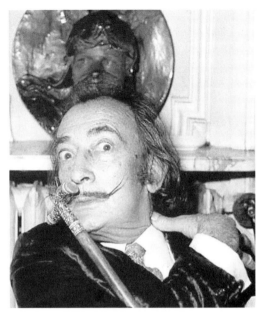

Portrait of Salvador Dalí, taken in Hôtel Meurice, Paris, 1972

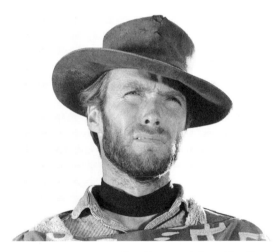

Clint Eastwood, from *The Good, the Bad and the Ugly*, 1966

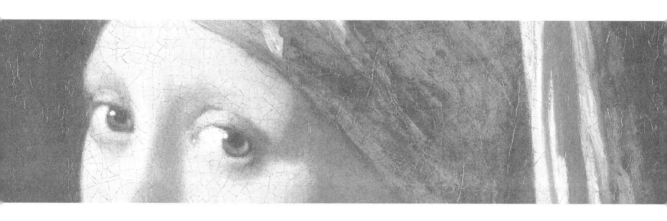

Johannes Vermeer (1632–1675), Girl with a Pearl Earring (c. 1665).
Mauritshuis, The Hague, Netherlands.

Seeking and Finding the Dominant Eye

Modern life provides an opportunity never before available in the long span of human history to study, in an impersonal way, live, in-motion human facial expressions: television close-ups. Starting in the early 1940s with the advent of home television, we have had close-up images of live human faces to observe and contemplate. Today, we can sit or stand in front of a television set, with the sound on or off, and truly *see* a human face in action without the inhibiting effect of closely studying someone's face in real life. Television offers a perfect chance to practice finding the dominant eye.

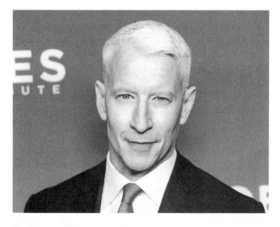

Anderson Cooper at the 12th Annual CNN Heroes ceremony, December 9, 2018

Try this: find a news broadcast that shows a reporter or commentator fairly close up, head and shoulders only, facing forward toward the camera. Focus briefly on one eye and then on the other eye. If the reporter is reading from a teleprompter, all the better to activate the verbally connected dominant eye. Which eye is visibly attending to the words being read and spoken? Which eye seems to be *not* following the words but instead is "just there," looking a bit remote? Which eyebrow is pushed forward toward the midline of the face, and which eyebrow is pulled back from the midline, thus encouraging you to focus on the active, dominant eye? Is the head slightly turned so that the half of the face with the dominant eye is pushed slightly forward? If

the televised person is of an older generation, do you see wrinkles or creases between the eyebrows that seem to "point to" the dominant eye?

Soon, with some practice, the slight difference between the two sides of a TV speaker's face will become apparent— the subdominant side, with its dreamy eye and eyebrow pushed forward toward the face's midline, will lead you to focus on the active dominant eye. And if you try to shift your focus back to the subdominant eye, you will likely find that it feels off-target, leading to an urge to return your focus to the dominant eye.

In time, these "seeing strategies" become almost automatic, and the transfer of your "seeing skills" from TV images to live, face-to-face perceptions also becomes automatic, a practice and habit that may prove to be helpful in personal relationships, since we all seem to be trying subconsciously to connect dominant eye to dominant eye.

Which brings me to a slightly wicked ploy that I feel hesitant to include but which has so interested me that I can't resist. If, by chance, you find yourself in a conversation with a hostile person, find the person's dominant eye and then shift your focus to gazing steadily with both eyes, in this case, into the person's *subdominant* eye. The hostile person may try some of the maneuvers previously discussed to shift your gaze to their dominant eye. But if you persist in steadily gazing into the person's subdominant eye, that person will likely cut short the hostile encounter and leave you.

SEEING AND NOT-SEEING:

Pre-instruction and Post-instruction Drawings

In our five-day drawing workshop, the first thing that our students produce, before any instruction begins, is a self-portrait. (I hear groans.) To ease the anxiety, we explain that we need this drawing as a record of where they are starting out in terms of skill level. Otherwise, we will have nothing by which the students themselves can see and compare their progress over five days of instruction, with the final drawing also being a self-portrait. We explain that we will collect the pre-instruction self-portraits without comment and only bring them out on the last day of the workshop.

One of the reasons we ask our students for the pre-instruction self-portraits (which do create a lot of anxiety) is that an odd kind of amnesia sets in over the five-day course about their skill levels starting out. We have actually had students who did not recognize their

Left: Janet Kistler
Before instruction
September 10, 2018

Right: Janet Kistler
After instruction
September 14, 2018

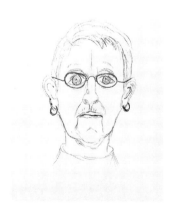

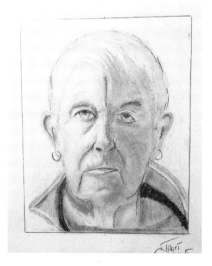

pre-instruction drawings, and only because their signature was on the drawing could they accept the evidence of where they had begun.

STUDENTS' SELF-PORTRAITS
AND DOMINANT EYES

This practice of comparing pre- and post-instruction drawings has been part of the process that has led me to the subject of this book, dominant eyes or "eyedness." Over the years, I have observed that students' pre-instruction self-portraits almost always show symmetrical eyes—each eye is a duplicate of the other eye. In contrast, the post-instruction self-portraits, drawn on the last day of the five-day workshop, often show a difference between the two eyes, with one eye being clearly dominant, even though there was no discussion of eye dominance in the workshop. Apparently, students had *seen and drawn* the difference without conscious (verbal) awareness (see pages 52 and 53).

Learning to draw, then, seems to bring at least *visual* awareness (if not verbal awareness) of a key aspect of our own faces: for most of our faces, one eye dominates. And this visual awareness, whether conscious or not, shows up repeatedly in the self-portraits of accomplished artists.

SELF-PORTRAITS AND PORTRAITS BY
WELL-KNOWN ARTISTS AND PHOTOGRAPHERS

If we closely observe self-portraits by famous artists, we often find emphasis on one eye, presumably the dominant

Monica Richardson
Before instruction
February 19, 2018

Monica Richardson
After instruction
February 23, 2018

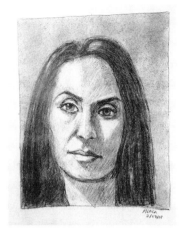

Sean Hanson
Before instruction
May 20, 2019

Sean Hanson
After instruction
May 24, 2019

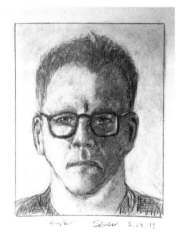

Stephanie Mulvany
Before instruction
January 3, 2018

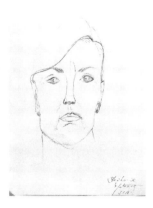

Stephanie Mulvany
After instruction
January 7, 2018

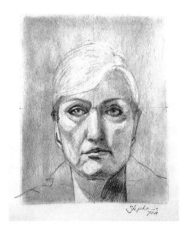

Bob Rinaoloa
Before instruction
November 4, 2019

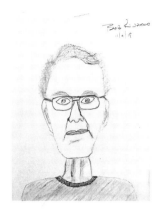

Bob Rinaoloa
After instruction
November 8, 2019

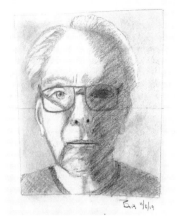

Ajoke Esther David
Before instruction
April 25, 2019

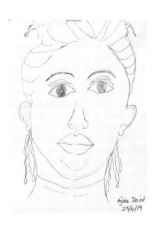

Ajoke Esther David
After instruction
April 29, 2019

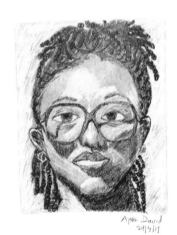

Nick Fredman
Before instruction
April 8, 2017

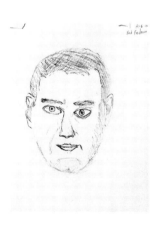

Nick Fredman
After instruction
April 12, 2017

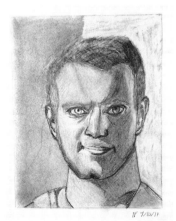

eye. Or, in some self-portraits, artists simply leave the subdominant eye more or less "out of the picture," receding in deep shadow, smudged into indefiniteness in three-quarter views (showing one-half of the whole face on the forward side, and one-quarter of the whole face on the turned side, thus the so-called three-quarter view). That

A self-portrait of the young Picasso, painted at the age of fifteen

Pablo Picasso (1881–1973), Self-Portrait (1896). Oil on canvas, 32 x 23,6 cm. Museu Picasso, Barcelona. Photo Credit: Album / Art Resource, NY. © 2020 Estate of Pablo Picasso / Artists Rights Society (ARS), New York.

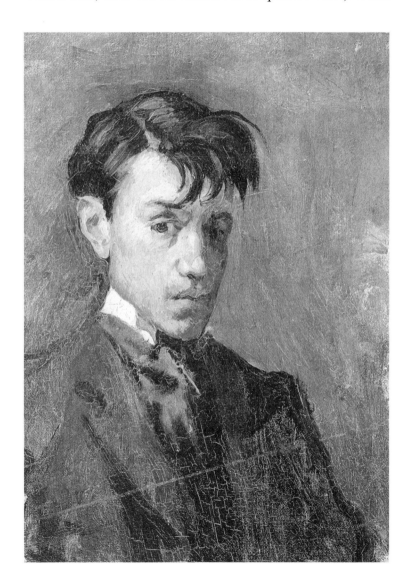

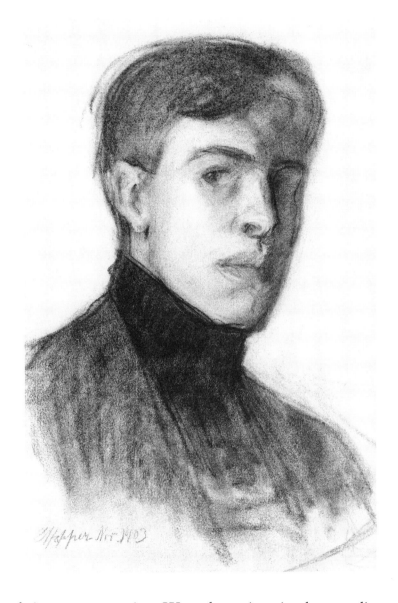

Edward Hopper was twenty-one when he sketched this quietly confident self-portrait.

Edward Hopper (1882–1967), Self-Portrait (1903). © 2020 Heirs of Josephine N. Hopper / Licensed by Artists Rights Society (ARS), NY. National Portrait Gallery, Smithsonian Institution.

brings up a question: Were the artists simply recording the difference as a matter of acute observation, or perhaps as an aesthetic decision to emphasize one eye over the other, or was there conscious awareness of eye differences in terms of function?

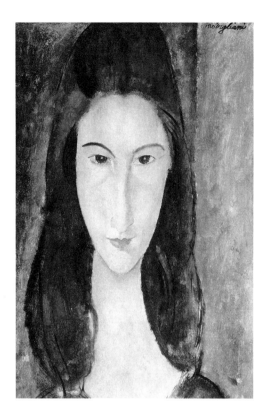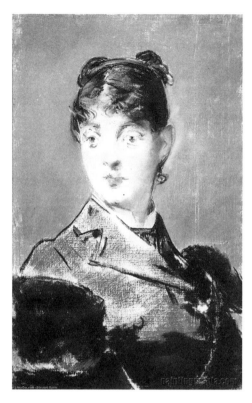

Left: *Amedeo Modigliani, Head of Jeanne Hébuterne (1918). Private Collection.*

Right: *Édouard Manet,* Parisienne (Portrait of Madame Jules Guillemet) *(1880), pastel on canvas. Ordrupgaard Collection, Copenhagen.*

In examples of artists painting portraits of friends, family, models, or paying customers, they appear to be simply portraying what they were seeing: one eye often clearly dominant and the other eye clearly subdominant and not the focus of attention.

There is an exception to that usual practice. When male artists paint portraits of young, beautiful female sitters, we often see an interesting change of eye focus. Male artists frequently pose these sitters in the three-quarter view, and a review of art-historical portraits shows that the young female sitter's *left, subdominant* eye (the soft, dreamy, nonverbal, nonchallenging eye) is primarily in

the forward position, while the alert, verbally connected, possibly challenging dominant eye is in the lesser, receding, one-quarter view position. Is this accidental? Is there a bit of wishful thinking going on here?

If you look closely at the face of Johannes Vermeer's *Girl with a Pearl Earring*, you will see a perfect illustration of this idea. The sitter's left (presumably subdominant) eye is in the forward position, with a soft, somewhat unfocused and dreamy expression, while her right eye (presumably the dominant eye) is in the farther-away position, yet looks directly at you, the viewer, with an alert, active, *connected* expression. To see this difference more clearly, try covering one half of the face and then the other half.

Viewing works of art that portray the observable difference between eyes is wonderful practice for learning to find the dominant eye in real-life encounters. The internet is a bountiful source of museum holdings of portraits and self-portraits for such practice, and searching and finding dominant eyes can enhance the enjoyment of viewing great works of art like the Vermeer painting.

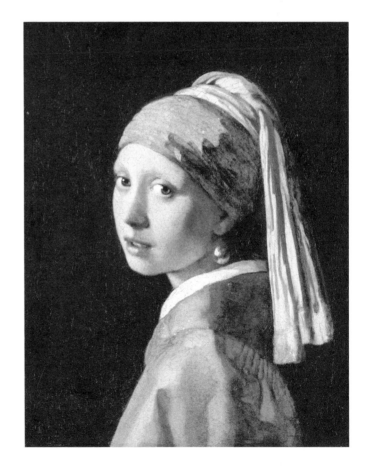

Johannes Vermeer (1632–1675), Girl with a Pearl Earring (c. 1665). Mauritshuis, The Hague, Netherlands.

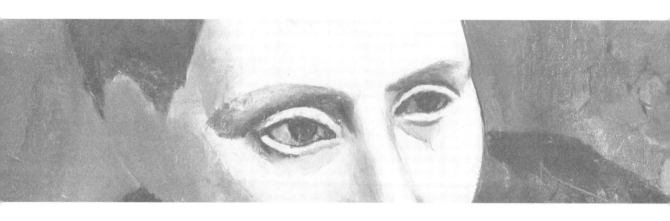

Drawing and the Symbolism of Eyes and Eyedness

Throughout my teaching career, along with countless other art teachers, I have said, "Learning to draw is not about learning to draw. It is about learning to see." To recap for a moment, the five basic seeing skills outlined in Chapter One that enable drawing are the perception of edges, spaces, relationships, lights and shadows, and the whole (the gestalt).

To give you some practice in putting those skills to use, I start this chapter with three drawing exercises that will introduce you to the first three of the five basic skills of drawing: Exercise One, seeing and drawing edges; Exercise Two, seeing and drawing negative spaces; and Exercise Three, a brief introduction to seeing and drawing the relationships of angles and proportions.

In this book, because the subject is eyedness, the drawing exercises are very simplified, with the only intent being to illustrate the basic perceptual skills.

EXERCISE ONE: A Negative-Space Drawing of an Ordinary Household Object

You will need a sheet of printer/typing paper, a pencil (an ordinary #2 yellow pencil; its eraser is sufficient), and a wide-tooth comb.

1. With your pencil, very lightly draw a format edge on your paper, a rectangle about 3½ inches high by 3 inches wide.

2. Lay just the end of the comb on top of the rectangle on your paper. Move it around until you find a placement that you like, and then use your pencil to trace around the edges of the comb and its teeth.

3. Erase the rectangle edge where the comb goes off the picture. This leaves you with a negative space that has a "shape" of its own.

4. Finally, use your pencil to fill the negative space with crosshatches. Note: if you keep your hatch marks going in more or less the same direction, the result will be beautiful. Or you may find your own style for hatching the negative space that will also be beautiful. There are countless personal styles of hatchmarks in drawing. They are the individual artist's "signature."

 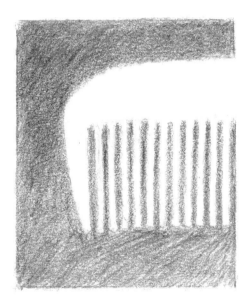

Drawings by Brian Bomeisler

You will end with a drawing that gives equal emphasis to both the negative space and the positive form, making this simple exercise effective as a drawing. The reason, I

believe, is that the space and the shape in the drawing are *unified*—locked in together, one no more important than the other. And, veering for a moment into aesthetics, we all long for unity in its many forms.

EXERCISE TWO: A Negative-Space Drawing of a More Complicated Object

Find a second, more complicated object for a negative-space drawing. You could choose a corkscrew or a pair of scissors (see the accompanying drawings), a vegetable peeler, or any object that has a somewhat more detailed shape.

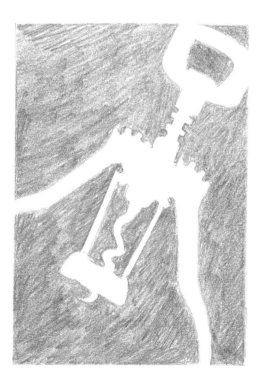

Drawings by Brian Bomeisler

1. Start by drawing on your paper a rectangular format edge that is slightly smaller than the object you have chosen (you want the rectangle to be slightly smaller than the object so that your drawing of it will go out of the edge of the rectangle). This is important, because you want the negative spaces to be independent shapes.

2. Again, lay the object on the paper and use your pencil to draw around each part of it, stopping at the framing edge. (Tracing around the object may distort the form a bit, but you can either make the correction or leave the distortion as is.)

3. Erase the edges of the format where the object goes off it. This will leave the shapes of the negative spaces clear for the next step of hatching in the negative spaces with your pencil.

4. Proceed to darken the negative spaces with your own style of hatching. Again, you have unified the positive object and the negative spaces by giving equal emphasis to both.

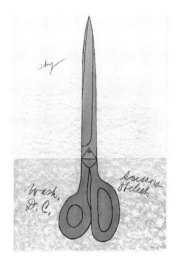

Oldenburg, Claes (1929-), Scissors as Monument, from National Collection of Fine Arts Portfolio (1967, published 1968). Lithograph from a portfolio of five lithographs, one etching, and one screenprint; composition (irreg.): 28 1/16 x 18" (71.3 x 45.7 cm); sheet: 30 1/16 x 20" (76.3 x 50.8 cm). Publisher: HKL Ltd., New York. Printer: Atelier Mourlot, Ltd., New York. Edition: 144. Gift of Mr. and Mrs. Lester Francis Avnet. The Museum of Modern Art, New York, NY. Digital Image © The Museum of Modern Art/Licensed by SCALA / Art Resource, NY.

EXERCISE THREE: A First Step in Drawing Relationships of Angles and Proportions

This exercise focuses on creating the impression of three-dimensional objects on a flat piece of paper. For individuals who have never learned to draw, this is often what they most long to achieve: to make drawings that "look real." This same longing also existed among artists centuries ago, during the Middle Ages and the Early Renaissance.

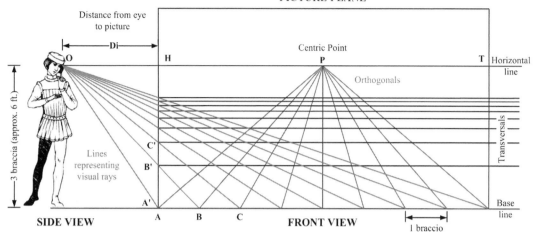

PICTURE PLANE

Distance from eye
to picture

Di

3 braccia (approx. 6 ft.)

O

H

Centric Point
P

Orthogonals

T

Horizontal
line

Transversals

Lines
representing
visual rays

C'

B'

A'

A B C

Base
line

SIDE VIEW

FRONT VIEW

1 braccio

Alberti's Perspective Construction.
From Alberti's Della Pittura.

During the Italian Renaissance in the early 1420s, artists Filippo Brunelleschi and Leon Battista Alberti were avidly working on the problem of representing in a drawing or a painting how things appear to us in real life, because we see the world as three-dimensional. Objects we know to be the same size appear to be smaller when one object is farther away. Edges that we know to be parallel (roads or, in modern times, railroad tracks) appear to come together at a vanishing point as they go back in space to the horizon line. Edges of the roofs of buildings that we know to be horizontal appear to be at angles when we know they are not.

The story goes that Alberti, standing in front of a window looking out at a city street, had an aha! insight: if he drew directly on the window glass with a wax crayon what he was viewing through the glass, he could depict on the flat glass the three-dimensional scene behind the glass.

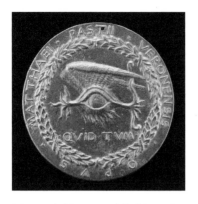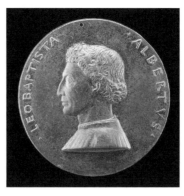

Matteo de' Pasti, Medal of Leon Battista Alberti (1404–1472), architect and writer on art and science (obverse); winged human eye (reverse) (1446–50), bronze, 9.3 cm (3¹¹⁄₁₆ in). National Gallery of Art, Washington, DC, Samuel H. Kress Collection.

Around 1450, Alberti designed for himself a portrait medal that was cast by the master Veronese medal maker Pasti. On the front is a profile of Alberti's mature face, his name in Latin along the rim: LEO BAPTISTA ALBERTVS. On the back is a somewhat mysterious image: a winged human eye, blood vessels and all, that Alberti used as his personal emblem. It may refer to the all-seeing eye of God, to the primacy of the eye for human inquiry, or even to Egyptian hieroglyphics, which fascinated many humanists. Underneath the eye is a short Latin phrase: QVID TVM ("WHAT NEXT?"). The image and phrase—highlighting the importance of information derived from the action of the eye—together embody the ambitions and intellectual energy of the Renaissance. Alberti himself praised the eye as if it were a god: "[It is] more powerful than anything, swifter, more worthy. . . . It is such as to be the first, chief, king, like a god of human parts. Why else did the ancients consider God as something akin to an eye, seeing all things and distinguishing each separate one?"*

* Leon Battista Alberti, Anuli, quoted in Patricia Lee Rubin, Images and Identity in Fifteenth-Century Florence (New Haven: Yale University Press, 2007), 93.

By 1435 in Florence, Italy, Brunelleschi had solved the problem and Alberti had put the solution in writing. Their brilliant work on the science of linear perspective and proportion was an enormous leap forward, enabling artists thereafter to realistically depict three-dimensional space on the flat surface of paper or canvas.

Linear perspective is complicated, involving horizon lines; converging lines; vanishing points; and one-point, two-point, and three-point perspective, and today it often becomes the ultimate frustration of many an art student.

In my view, learning difficult subjects never harms and always helps, but for the casual person who simply wants to learn to draw reasonably well, there is an easier way that I have found to be successful with students in our workshops. The method is called "sighting angles and proportions."

More specifically, "sighting" means using your eyes to estimate angles relative to vertical and horizontal and

You may be surprised that I am recommending that you use your cell phone, but it is a marvelous aid for drawing—a ready-made picture plane. In art history, artists have always welcomed any new technology that made drawing easier and better. In the nineteenth century, for example, artists quickly put photography to good use, and the quick, efficient cell phone cameras are a new step in that same direction.

proportions relative to each other. This method is not nearly as precise and accurate as linear perspective, but it works pretty well, and, to tell the truth, most artists today use this simpler method of creating the illusion of three-dimensional space on a flat drawing or painting surface.

For this method, you will need something to act as a "picture plane" (Alberti's window, so to speak), to flatten your view of the subject to the same two dimensions as the paper you will draw on. In our Drawing on the Right Side of the Brain workshops, we supply our students with a small clear-plastic picture plane, about 6" x 8", framed with black edges. For this exercise, you will use your cell phone for one picture plane, and your two hands to form a "frame" for another.

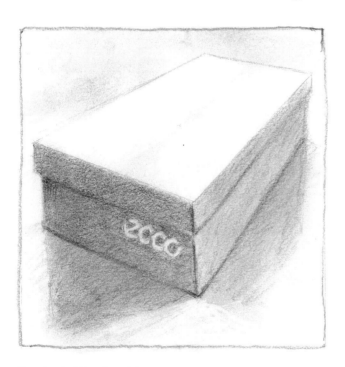

Drawing by Brian Bomeisler

Instructions for Exercise Three

1. **Find an ordinary box: a shoebox, a small cardboard box, any small box will do. (A thick book can also serve as a model.)**

2. **Set the box at an angle in front of you on a table so that one corner is forward and you can see three sides of the box: the front end, one side to the right, and the top of the box.**

3. Using your cell phone, take a photo of the box in that position. You will be quite surprised, I think, when you see in the photo (on the picture plane) the angles of the front face of the box and the angles of the side and top going back.

4. If your cell phone has a cropping function, adjust the size and shape of the framing edges to make an interesting composition of the box and the negative spaces around the box.

5. Next, make a "viewfinder" with your two hands (see drawing at right). Close one eye (to remove binocular vision and flatten your view) and frame the box with your hands and thumbs. (You will have to imagine the missing top edge of the format.) Look at the angles of the box edges relative to the vertical and horizontal edges of your "framing" hands. (Check out the angles again with your cell phone photo.)

Drawing by Betty Edwards

6. Decide what size and shape will be best for the outside frame (the "format") of your drawing: a square or a vertical rectangle or a horizontal rectangle, again using your framing hands and cell phone picture plane to help you decide.

7. Proceed to draw the format, the shape that you feel will best enclose the shape of the box and leave a bit of "air" (negative spaces) around it. Make sure that each corner of the format is a right angle. An important point: once drawn, the format edges represent vertical and horizontal.

8. Then, start your drawing with the leading vertical corner of the box—the edge closest to you. First, decide what size that edge is relative to the height of the format. Look again at your cell phone picture plane. This first size will determine the size of every other edge, so take your time to get this first move right. If you draw this nearest vertical corner too large, the box won't fit inside your format. If you draw it too small, the box will float inside a format too large for it.

9. Next, frame the box again with your hands and close one eye to check the angle of the bottom edge of the forward end of the box. Ask yourself, "What is the angle of that edge *relative to* the horizontal bottom edge of the format?" Draw that bottom edge of the box, then check it again with your framing hands and closed eye (and with the cell phone picture plane, if you wish).

10. Estimate the width of that bottom edge relative to the vertical leading edge you have already drawn. Again, close one eye, form your viewfinder with your hands, and check it out.

11. Next, draw the other vertical edge on the left side of the facing end of the box. Check the height of that edge. Depending on the width of the box, it may be *very* slightly shorter than the leading edge (it is slightly farther away).

12. Continue to draw each edge of the box going back, each time framing the view with your hands, closing one eye, and estimating the angle of each edge *in relation to the vertical and horizontal edges of the format*. For the *size* (length or width) of any edge, use that

first leading edge you drew as your basic size against which to estimate all the other sizes. Don't forget that you can always check those relationships with the cell phone picture plane as well.

13. Finish your drawing by shading in any lights or shadows you see on the box, or shadows that have been cast by the box (a small practice in the fourth skill, the perception of lights and shadows).

I hope you have ended up with a believable "perspective" drawing of a box, using the third perceptual skill, the perception of relationships (of angles and proportions). Once you have drawn this seemingly simple subject and caught on to this method of sighting proportions and perspective with one eye closed, trust me when I say that the whole world of drawing still lifes, landscapes, and interiors and exteriors of buildings is opened up to you.

Someone may then ask you, "How do you make your drawings look so real?" You will say, "I just draw what I see," or, to be perfectly truthful, you will say, "I just draw what I see on the picture plane."

VERBAL VS. VISUAL INSTRUCTION IN DRAWING

As I am sure you have noticed, it takes a lot of words to give instructions for drawings, whereas if I could just show you rather than tell you, the process would be quicker and possibly clearer. The two systems, saying and seeing, are truly separate and different, but we need both, and my

hope is that these drawing exercises show that they can be compatible and useful in developing perceptual skills through drawing.

Incidentally, the more mechanical and technical skills of drawing—using a variety of drawing mediums, creating images using lines and "shading," creating textural effects, using various techniques such as erasing, smudging, cross-hatching, and so on—are minor skills relative to the all-important *seeing* skills.

THE RELATIONSHIP OF GOOD EYESIGHT TO LEARNING TO DRAW

Fortunately, most of us have good to excellent working eyesight, but at the same time, unknowingly, our seeing has a specific limitation. We are able to see and name, to see and use, to see and categorize, to see and navigate, to see and read, to write and record, to be able to see in all the ways that modern life requires—ways that are mainly linked to language. But most of us are unable to *see and draw*, because that is a different kind of seeing.

Replica of prehistoric rock paintings (c. 30,000 BC) of the Chauvet Cave, Ardèche, France, showing woolly rhinoceros, aurochs and wild horses

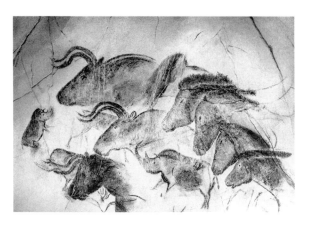

Drawing images of what we see requires the special seeing/drawing abilities you have just experienced, abilities that are apparently limited to human beings alone out of all the creatures of this planet (unless someday we find a chimpanzee or an elephant

out in the wild, drawing another chimpanzee or elephant). Amazingly, prehistoric humans practiced this singular innate human ability to see and draw in aesthetically beautiful, realistic cave drawings of animals created as long ago as 35,000 BC. Today, the practice of that innate capability is limited to a small minority of people. By not valuing and not continuing this specific kind of seeing, are we missing something? If in childhood we were all trained to draw, or to be proficient in all of the visual arts, the way that nearly all of us are trained today to read and speak and write, would it make a difference? And what kind of difference?

Franco-Cantabrian, Upper Palaeolithic period, 15,000–10,000 BC. Left wall of the rotunda in the cave at Lascaux (Dordogne, France).

SYMBOLIC DRAWING AND THE DEVELOPMENT OF HANDWRITING

In this chapter, I focus on the eons-long development that started with prehistoric drawings and spoken language, progressed to pictographs representing words, and eventually led to various forms of written language. We can only guess how this development happened, since we know so little about the earliest humans, *Homo sapiens*. But we do have the physical evidence that they were making drawings of wild animals, drawings that were not awkward and primitive, as one would expect. Instead, they were elegant, even sophisticated drawings, sensitive to

proportions, to the smallest realistic details of eyes and hooves, to capturing the very essence of a bull's or bison's nature. Moreover, they made these drawings *from memory*. Having seen animals in the wild, they were apparently able to recall and re-create incredible likenesses on the rough walls or ceilings of dark, deep caves dimly lit by torches, using paint or chalk.

A present-day artist, well-trained in drawing, would be hard put to equal that achievement. Many scientists have wondered how the cave artists did what they did. One scientist, who had drawing skills himself and was puzzled by the achievement of the cave artists, even suggested that dead animals might have been dragged into the caves to serve as models. This theory was dismissed by other scientists who gamed out the improbability of that explanation, given the narrowness of cave passageways and the sheer weight of large dead animals.

The inescapable explanation for the beauty and quality of ancient cave art seems to be that prehistoric humans had an incredible innate capability to accurately see and beautifully draw. Over the following centuries, early humans and their descendants put that capability to use to develop an entirely different set of skills, how to preserve spoken language by converting it first to pictures and eventually to writing. The dominance of written language over seeing/drawing is now complete: language, words, and writing largely rule human life. The greatest benefit of writing is that it can preserve

thoughts and information clearly and unambiguously. As the American poet, novelist, and playwright Gertrude Stein wrote, "A rose is a rose is a rose," and Albert Einstein stated in writing, "$E = mc^2$."

The conversion from drawing to writing was long and slow. Small drawings in clusters, called "pictographs," were the early start of modern writing systems. Tiny drawn images of, say, a human, a spear, and a bison told a story: a person killed a bison with a spear. Pictographs were effective at storytelling but complicated to draw, and not easily adaptable to more prosaic uses. As people settled into communities, planted crops, and began trade that gradually required record keeping, they developed simpler, less pictorial forms of recording ownership than, say, drawing six tiny symbolic goats.

Starting around 2800 BC, the Sumerians and Babylonians invented cuneiform writing, using narrow, wedge-shaped reed styluses to stamp records into soft clay pads which were then dried or baked in fire to preserve the message. The stamped pads could then even be wrapped in soft clay "envelopes" for privacy and delivered to recipients. Cuneiform writing represented numbers for

In portraying his friend, Picasso notably emphasized Gertrude Stein's clearly dominant right eye.

Pablo Picasso (1881–1973), Gertrude Stein (1905–6). © 2020 Estate of Pablo Picasso / Artists Rights Society (ARS), New York.

Hollow clay cylinder describes, in cuneiform, Sin-iddinam's dredging of the Tigris on behalf of various deities.

counting and symbols for the sounds of language rather than abstracted images of objects—clearly a more flexible, efficient, and useful form of writing.

Early Egyptians developed their pictorial writing, called hieroglyphs, or "language of the gods," not long after the advent of Sumerian cuneiform writing. To accommodate increasingly complex ideas, the number of separate Egyptian hieroglyphs grew at one point to more than a thousand.

Fragment of the wall decoration of the tomb of Seti I (c. 1294–1279 BC), 19th Dynasty. New Kingdom.

A	**B**	**C**	**D**	**E**	**F**	**G**
H	**I**	**J**	**K**	**L**	**M**	**N**
O	**P**	**Q**	**R**	**S**	**T**	**U**
V	**W**	**X**	**Y**	**Z**		

The Egyptian hieroglyphic script was one of the writing systems used by ancient Egyptians to represent their language. Because of the scripts' pictorial elegance, Herodotus and other important Greeks believed that Egyptian hieroglyphs were something sacred, so they referred to them as holy writing. Thus, the word "hieroglyph" comes from the Greek *hiero* (holy) and *glypho* (writing). In the ancient Egyptian language, hieroglyphs were called *medu netjer,* or "the gods' words," as it was believed that writing was an invention of the gods.

The earliest form of the Phoenician alphabet, dated around 1000 BC, contained twenty-two consonants but no vowels and was spread across the Mediterranean world by merchants keeping records. The next developments were the Aramaic alphabet, then the Greek alphabet, followed by the Latin alphabet that we use today, which added vowels to the consonants to form a complete alphabet representing spoken words.

Evolution of Greek and Latin Alphabets

Phoenician	∢	⊿	⅂	△	∃	Υ	I	⊟	⊕	⅄	⅄	⅃	⅄	⅄	≠	O	⊃	⋎	φ	⅂	W	+								
Early Greek	A	ꓭ	⅂	△	Ǝ	⅂	Z	H	Θ	I	Ж	⋏	ᛗ	И	Ξ	O	Π	M	Q	P	Σ	T	Y			Φ	X	Ψ		
Later Greek	A	B	Γ	△	E	F	Z	H	Θ	I	K	⋏	M	N	Ξ	O	Π		Q	P	Σ	T	Y			Φ	X	Ψ	Ω	
Etruscan	ꓮ		⟩		⅃	⅂	⧺	ꓐ	O	I		⅃	ᛗ	ᴨ		ꓯ	M		ꓒ	⟩	†	V			φ	↓				ꝸ
Early Latin	A	B	CG	D	E	F	Z	H		I	K	L	M	N		O	P		Q	R	S	T	V	Y	X					
Later Latin	A	B	CG	D	E	F	Z	H		IJ	K	L	M	N		O	P		Q	R	S	T	U	V	W	Y	X			

Image by George Boeree

Quill pens were made from the flight feathers discarded by large birds during their annual molting season. The hollow shaft of the feather held ink that flowed to the tip via capillary action.

Along with these developments in writing, originally created for record keeping and later expanded for cultural and historical record keeping as well as imaginative story-telling, a class of artisans or scribes (always male) arose as an elite, specialized group—the graphic artists of their time. Soon, the scribes' ink, reed brushes, pigments, and parchment replaced the soft clay tablets and styluses of the Phoenicians. Later, in turn, those writing tools were replaced by quill pens, ink, and papyrus and, eventually, by quill pens, ink, and paper.

Amazingly, quill pens persisted as the primary writing instrument in the western world from the sixth century BC to the nineteenth century AD and were used to write the United States Declaration of Independence and Con-stitution. Even today, quill writing sets are sold on the

First Fig
Edna H. Vincent Millay

My candle burns at both ends;
It will not last the night;
But ah, my foes, and oh, my friends—
It gives a lovely light!

Handwritten by Sharon Lawrence

internet, and beautiful cursive handwriting and calligraphy are still practiced by a small group of people.

Now, however, the long human history of drawing leading to handwriting seems to be coming to an end. Mechanical writing, starting with Johannes Gutenberg's invention of the movable type printing press around AD 1436, superseded labor-intensive handwriting and enabled a dramatic diffusion of knowledge. Historians claim that the invention of the printing press "dwarfed in scale anything which had occurred since the invention of writing"[4] and provides the closest parallel to the emergence of the internet in terms of impact on human life. Today, unfortunately, handwriting is increasingly rarely taught in our schools, and, incredibly, some of our younger students have not even developed personal signatures. They are unable, when asked, to legibly sign their names. Decorative signatures are becoming the equivalent of the iconic "X," some with no letter forms at all, just marks.

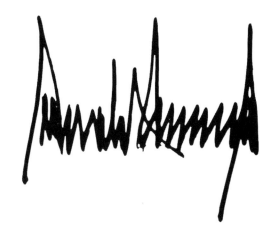

Donald J. Trump, president of the United States

Tim Cook, Chief Executive Officer of Apple

Jacob J. Lew, Secretary of the Treasury of the United States, 2013–2017

[4] J. Roberts, *The Penguin History of Europe* (New York: Penguin, 2004).

SYMBOLIC DRAWINGS:
Images as Visual Shorthand

One way in which drawing *has* persisted over time is symbolic drawing, memorized simplified images, mechanically reproduced, that stand for something else, usually a large visual or verbal idea or concept, or an organization. Today these symbols can be as simple as directional arrows (showing the way forward) or the small signs of arithmetic, which represent the very large ideas of adding, subtracting, multiplying, or dividing. Or symbols can be as elaborate as flags, representing whole countries, complex (or simple) logos standing for huge corporations, or abstract designs representing all-encompassing spiritual ideas.

See hidden arrow

Target logo

Twitter logo

Christianity Catholicism Protestantism Eastern Orthodox Islam Judaism Bahai Faith

Buddhism Theravada Mahayana Vajrayana Taoism Confucianism Caodaism

Hinduism Sikhism Jainism Ayyavazhi Shinto Tenkikyo Ryukyuan Religion

Babism Rastafari Mandaeans Akan Religion Wicca Paganism Atheism

SYMBOLIC EYES FROM ANCIENT TIMES TO NOW

Included among the earliest symbolic images and continuing throughout recorded human history were simplified eyes. At first, each eye was formed by two curved lines enclosing a circle or large dot, the iris of the eye. Small "eye idols," excavated from Syria and dating from before 3500 BC, were symbolic forms that might have stood for "eyes to see with" or "eyes to be seen by," or eyes that later became the "windows to the soul."

Over time, distinctions developed between the right eye and the left eye, with the right eye linked to daylight, the sun, and benign intentions, and the left eye to darkness, the moon, and uncertainty. For example, early Egyptians believed that the right eye held solar traits of the sun, while the left eye possessed lunar, or moon, traits. Additionally, the right eye represented the south (warmth and light), while the left eye represented the north (cold and dark). These early distinctions of light and dark, day and night, might possibly be linked to an early intuitive grasp of the right eye's link to language and the left eye's link to nonverbal observation.

The All-Seeing Eye

Gradually, symbolic images of the two eyes became one eye, the "all-seeing eye." Early depictions of the all-seeing

Eye idols carved out of gypsum alabaster have been excavated at Tell Brak, Syria, and are believed to date from before 3500 BC.

Eye idol, (Middle Uruk period, c. 3700–3500 BC), Gypsum alabaster. The Metropolitan Museum of Art, New York. Gift of The Institute of Archaeology, The University of London, 1951.

eye were generally calm and nonjudgmental, an eye neither widened nor narrowed by petty human emotions, neither approving nor disapproving. The eye image became all-seeing, all-powerful, like the sun itself, simply there.

In countless forms, this image has appeared and reappeared from as early as 3000 BC to today's modern world.

For example, the 2013 New Year's Eve ceremony in Sydney, Australia, featured a huge eye symbol, 12 stories high and 236 feet long, formed of lights, the iris intensely blue, framed by the curved "eyebrow" of the Sydney Harbour Bridge. This enormous, startling eye appeared at the stroke of midnight on the bridge.

New Year's Eve "Eye" on the bridge over Sydney Harbor

Photo: Gordon McComiskie / Newspix

The Old New Eye: The Imagined "Third Eye"

In India, also around 3000 BC, the depiction of a "third eye" appeared in the Sanskrit text the Rigveda. The Hindu god Shiva had three eyes: the right eye said to represent the sun; the left eye, the moon; and the third eye, the fire that can destroy all evil and ignorance. The flame-shaped third eye was centered between and above the eyebrows. Talismans for the Eyes of Shiva are worn even today

Statue of Lord Shiva at Murudeshwara Temple in Karnataka, India

as an amulet for gaining wisdom and protection from harm.

The Buddha represents the Eye of the World, noted for his wisdom and compassion. Siddhartha Gautama, the charismatic teacher who in the fifth century BC in Nepal eventually became the Buddha, or the "Awakened One," emphasized during his lifetime the need to test one's ideas and views and not to blindly accept other's rules and guidelines. Siddhartha Gautama promoted the quality of mindfulness—awareness without judgment. No actual images of Siddhartha Gautama exist, but later imagined images of the Buddha's face often show a dot between the brows representing the third eye.

Head of the Buddha as a young man (4th–5th century). Collection Victoria and Albert Museum, London.

The Eye of Horus, One of the Most Beautiful of All the Eye Symbols

In ancient Egypt, Horus was the sky god who was usually depicted as a falcon. The symbol for Horus, the beautiful "Eye of Horus," echoes the dark markings around the eyes of the peregrine falcon.

The design of the Eye of Horus, with its peregrine falcon–head markings, represented protection of the pharaoh in life and in the afterlife, royal power, and good health. In Egyptian mythology, the Eye of Horus was not

Left: The Eye of Horus

Right: Peregrine falcon

used just for ensuring the pharaoh's well-being but was also thought to be an active opponent of evil. Long after the end of the Egyptian dynasties, sailors painted the Eye of Horus on the hulls of ships for protection from disaster at sea.

The Pineal Gland and the Eye of Horus

Historically, we human beings have tended to tie unlikely things together if we detect similarity in some way—cases, one could say, of mistaken identity. We have equated thunder and lightning with anger of the gods, a black cat crossing one's path with the onset of bad luck, or the need to hang a blue bead in an entry door for protection from the evil eye of envy, a human look or glare believed to cause supernatural harm. The beautiful design of the Eye of Horus may have triggered a similar mistaken identity: the Eye of Horus became identified with an ultimate "third eye" embedded in the human brain itself.

The shape and pattern of the Eye of Horus appear to be similar to the shapes surrounding a tiny pine-cone-shaped gland called the pineal gland, located deep in the human midbrain, where the corpus callosum, the thalamus, and the pituitary glands are also located. By coincidence, the combination of these midbrain structures resembles the design of the falcon's markings that in turn are echoed in the design of the Eye of Horus. As you see in the diagram of the human midbrain, the corpus callosum looks like the eyebrow, the thalamus resembles the eyeball, the brain stem (the medulla oblongata) and the hypothalamus resemble the markings below the peregrine's eye and below the Eye of Horus, and the pineal gland completes the eye form.

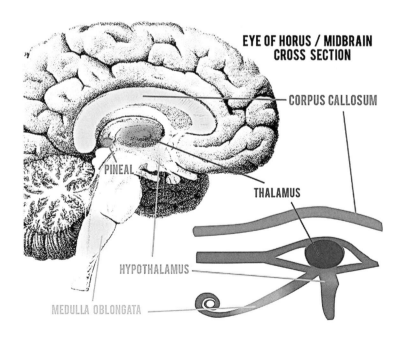

EYE OF HORUS / MIDBRAIN CROSS SECTION

CORPUS CALLOSUM

PINEAL

THALAMUS

HYPOTHALAMUS

MEDULLA OBLONGATA

As portrayed in this painting, a copy of a lost Frans Hals portrait, Descartes appears to be right-eye dominant. His left eye, hidden in shadow, appears to be less alert and focused than his right eye, which connects with the viewer of the portrait. Also, Descartes' left eyebrow seems to be pushed forward toward the center line of the face, and the right eyebrow is raised to emphasize the right eye.

After Frans Hals, Portrait of the Philosopher René Descartes *(1596–1650), (c. 1649–1700). Collection of the Dukes of Orléans in the 18th century; acquired by Louis XVI, 1785. Musée du Louvre, Paris.*

Seizing on this notable visual similarity in structure, and despite the distance from here to there, this midbrain structure early on became identified with the design of the all-seeing Eye of Horus. It was a small leap after that to identifying the pineal gland as an actual third eye and the center of divine consciousness embedded in the human midbrain. This idea, first conceived by early Egyptians (who were conducting postmortem human-brain studies), has persisted to this day, with many iterations along the way.

For example, despite his insistence that skepticism be an essential part of the scientific method, the French philosopher and brilliant mathematician René Descartes (1596–1650) declared, "The pineal gland is the principal seat of the soul."

And in 2015, a course website at the Pennsylvania State University posed the question: "Could the Pineal Gland Really Be the Third Eye?" Several scientists have independently proposed a hypothesis that the pineal gland is a relic, a vestige of a third eye. Their findings suggest that the pineal gland is a precursor to the modern eye, with photoreceptors present in both organs, and that the gland is the ultimate third eye, embedded in the brain itself.

Summing up, the pineal gland has been studied for centuries. There is even an entire publication devoted to the investigation, *Journal of Pineal Research*. The pine-cone-shaped gland appears to have some limited characteristics similar to a human eye and seems to benefit from increased sunlight and meditation. Is it our third eye? I say, stay tuned. Science will prevail.

The Evil Eye

Another singular aspect of eye imagery is the ever-present "evil eye," regarded as a curse conveyed through a malicious human glare, most often caused by envy. Throughout thousands of years, people have worn or carried eye amulets—tokens meant to ward off the curse of the evil eye.

A group of blue glass nazars, eye-shaped amulets believed to protect against the evil eye

The evil-eye image has been found in Sumerian cave drawings, as well as on ancient amulets from 3000 BC in Syria, and it appears in the writings of Virgil in Rome in the first century BC. The blue glass trinket, deemed an amulet, is itself thought to derive from the Ottoman Empire, which spread its version of the *nazar*, as it is called in Turkish, across the many lands it ruled. You can find many versions of evil-eye amulets across the world today.

Oddly, over the last decade, the evil eye and protective amulets against it have gained new favor in the modern world of fashion. Among others, Kim Kardashian, an American media personality, and Gigi Hadid, an American fashion model, have promoted evil-eye jewelry and clothing, attenuating the age-old human dread of the curse into mere curiosity and commerce.

Christianity, the "Eye of Providence," and the Symbol's Link to Freemasonry

Christian symbolism from about AD 1500 continues the tradition of a single, all-seeing Eye of Providence, frequently enclosed in a cloud-filled or "glory-filled" triangle representing the Holy Trinity.

With the rise of Freemasonry as an influence in early American governance, the eye-in-the-pyramid seems to have represented hopes for a new order in the land of the free under "the Almighty's watchful eye." In 1782, Congress incorporated the eye-in-the-pyramid into the reverse side of the Great Seal of the United States, and, in 1934, the

It is thought that the eye of God, painted above Christ's head, is a later addition.

Jacopo Pontormo (1494–1557), Supper at Emmaus (1525),
Oil on canvas, 230 x 173 cm. Galleria degli Uffizi, Florence.

symbol made a new appearance on the back of our one-dollar bill, arousing rumors of US governance links to Freemasonry, which had adopted the eye-in-the-triangle symbol for its somewhat secretive society in 1797.

Since 1934, the eye-in-the-pyramid and all-seeing eyes in general have appeared at random in American culture, providing evidence that such symbols over time tend to become more familiarized and accepted (or ignored) without questioning their origins.

There will always be people, however, who tend to see danger, conspiracy, and dread in ambiguous symbols like the all-seeing eye and in the more imaginative interpretations of such symbols. The Bible has many references to

Antioch, Turkey. Roman civilization, c. 2nd century AD. Mosaic from the so-called House of the Evil Eye, representing the evil eye being attacked by creatures and weapons.

eyes, both positive and negative. One of the best known is Matthew 5:29: "If thine right eye offend thee, pluck it out and cast it from you." The Roman mosaic from Antioch shows a full-blown attack on an offending eye, indeed a right eye, which, in this case, looks to be not only non-threatening but quite sad and defenseless.

THE EFFECTS OF LEARNING TO DRAW ON PERCEIVING REALITY

In this chapter, I have proposed that realistic drawing, which enables accurate seeing, came first in human history—long before writing. Drawing, which contributed greatly to the invention and perfection of writing, has in the process been largely overwhelmed by language and become lost as a form of human intelligence and expression.

Daniel M. Mendelowitz, a renowned teacher and author of a famous drawing instruction book from the 1970s, *A Guide to Drawing*, famously said, "That which I have not drawn I have not seen." If we listen to Mendelowitz, what has been lost is the ability to see the way an artist sees. As I have previously mentioned, our workshop students often speak about "seeing so much more" after learning to draw, whereas previously they were "just naming things." The amount of information that becomes available by drawing a single image compared to naming the image is well stated in the clichéd, timeworn saying "A picture is worth a thousand words."

These ideas of change do not apply to the "high art world" of museums and art galleries. Those institutions have always maintained their important, elite status and always will, though there have been some recent fearful rumblings that commerce is overtaking even that specialized world.

Television has become the true revealer of personality and character. In close-ups of speechifying individuals, the viewer's left brain evaluates the words while, simultaneously, the right hemisphere reacts to complex visual clues of personality and character that cannot be hidden or faked. People often say, "The words sounded OK, but there is something about this guy [or woman] that I don't trust." Or, conversely, someone might say, "I don't agree with the message, but he [or she] seems OK."

Gradually, however, a new change seems to have been taking place over the past hundred years. Visual imagery has begun to increasingly challenge the dominance of spoken and printed language in ordinary life.

Starting in the late nineteenth century, successive inventions such as photography, followed by cinema and then television, have changed our world. Today's computers, the internet, and handheld devices like cell phones can provide images on demand for almost any subject. Today we live in an image-rich environment, filled with emojis, Instagram, Pinterest, and video conferencing like Zoom, which, over time, may evolve into a new world of improved and broadened visual perception with less dependence on language in all its forms.

Reinstating drawing into early-childhood education could promote understanding. Drawing slows down perception. Visual information that might be glossed over, or actually not seen at all in more casual "looking and naming," provides a pathway to the real goal, *understanding*. This is the difference between fast seeing in order to name, and slow seeing through drawing, which provides a pathway to those true goals of drawing: perception, comprehension, and appreciation.

THE QUESTION: What to draw?
THE ANSWER: Anything at all.

Try this out—again, don't be concerned if you haven't drawn in the past. Set aside fifteen or twenty minutes in

which you will not be interrupted. Gather materials—a sheet of plain printer paper, a pencil, and an eraser. Find some simple object to draw:

- a fallen dried leaf
- a shell
- a flower
- a stem of broccoli
- a crumpled-up Post-it Note
- a key ring with several keys

Set your timer for fifteen or twenty minutes and begin to draw. Try to include every detail you see in your subject—every jog of an edge, every negative space,[5] each change in darkness or lightness, every contour. Try to keep on drawing until the timer sounds. Keep your eyes mainly focused on the object—that is where the information is that you need for the drawing. As you draw, you will find yourself feeling surprised at how complicated your seemingly simple, ordinary model is, and, unexpectedly, how beautiful.

When the timer sounds and you sit back to regard your drawing, try to look at it as a record of perception, a reminder of the experience. I predict that the image will live in your memory for quite a long time, and an encounter

Drawings by Betty Edwards

5 See the exercise in Chapter Five for more information about negative space.

with a similar object will vividly call up the drawing experience. That is the essence of drawing: understanding in a new and different way what you have drawn—a reminder of the beauty and complexity of our planet world.

EYE DRAWINGS TODAY IN THE HANDS OF TATTOO ARTISTS

Last, an encouraging sign of the revival of right-hemisphere drawing skills is the surprising present-day resurgence of tattooing. The all-seeing eye, the Eye of Providence, and the evil eye survive today in this unexpected form. Tattoos have been part of human history for thousands of years, as components of rituals and cultures around the world. This practice of permanently drawing on human skin has been alternately revered and reviled over the centuries. Thirty years ago, tattoos mostly adorned prison inmates, sailors, and motorcycle gang members. Now, surprisingly, tattoos have burst into popular culture. According to the Pew Research Center, 36 percent of Americans under the age of twenty-five have at least one tattoo. Tattoo artists have become celebrities, famous for customized designs, and TV dramas like *Black Ink Crew* and *Ink Master* are rapidly erasing the linkage of tattoos with an underclass and underworld.

Currently, the all-seeing eye is a favorite tattoo subject—from the elegant Eye of Horus to decorative, often multicolor, hyperrealistic tattooed single eyes in fanciful settings.

Perhaps this is a sign of things to come: a return to an upbeat, joyful, visual/perceptual period of human history, with drawing as a lead-in to greater understanding of our planet and ourselves.

Various popular tattoo patterns and designs.

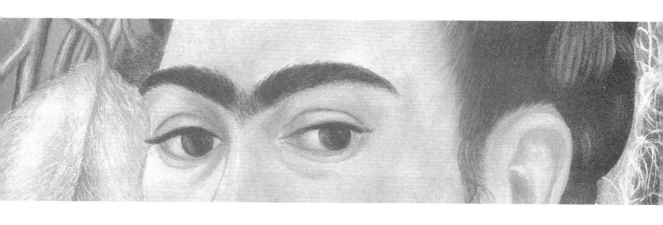

Why Do We Make Portraits of Ourselves and Other People?

ortraiture is a very old art form dating back at least to ancient Egypt, where it flourished starting about five thousand years ago. At that time, a painted, sculpted, or drawn portrait was the only way to record a person's appearance. In modern life, we live in a world of portraits. At home, we have photographs of family and friends. On television, in between newscasts and programs, we see formal photographic portraits of the newscasters or TV personalities—often highly retouched and idealized. Faces today are on book covers, in newspapers, in magazines in the supermarket. Facial expressions in these photographic portraits are carefully

A portrait is a painting, photograph, sculpture, or other artistic representation of a person in which the face and its expression is usually the main focus. The intent is to display the likeness, personality, and even the mood of the sitter. That intent is carried out by an artist, who can impose their own inclination or personality on the portrait, making it always a bit chancy to sit for a painted or drawn portrait. With photographic portraits, the sitter can often choose from a group of test photos, gaining some control over the final portrait.

Pharaoh Akhenaton, King of Egypt, 1353 BCE to 1335 BCE. Collection Egyptian Museum, Cairo.

calibrated to express the exact desired effect: loving kindness, intellectual heft, ironic humor, provocation of all sorts, serious concern, carefree joie de vivre.

In general, early portraits were of people from the ruling class, and the artists, too, were an elite group. Portraiture was not for ordinary people and self-portraits were exceedingly rare, in part because mirrors were small, uncommon, and costly. They were mostly made of polished black volcanic glass called obsidian, or polished copper or silver, and were seldom perfectly smooth. With these materials, the reflected image must have been something like seeing one's face in a tiny dark pool of water.

The invention of glass mirrors, backed with a metallic coating that gave a true and accurate reflection of a face, finally became available in the early years of the Renaissance in Europe, and undoubtedly helped to inspire artists to paint self-portraits—paintings of the artist by the

Some art historians have suggested that Van Eyck might have intended the turban to serve as an advertisement of his superb painterly ability.

Jan van Eyck (c. 1395–1441), Portrait of a Man (Self Portrait?) (1433). The National Gallery, London.

artist. One of the earliest of these self-portraits was by the Flemish artist Jan van Eyck (1385 or 1390–1441). His *Portrait of a Man* was painted in 1433. Van Eyck painted his image in three-quarter view, gazing directly into his own eyes in one of the newly clear and accurate mirrors (and, thus, directly into the eyes of the future viewer of the painting).

The painting is sometimes known as "The Man in the Red Turban," possibly because the turban is quite spectacular in its beautifully painted billowing crimson folds and wrappings, overshadowing the artist's face and his somewhat off-putting, ambiguous expression.

I am guessing that Van Eyck's right eye (the eye on the left side of the painting—he is working from the mirror image of his face) is the dominant eye. It looks directly at the viewer with a cool, uncommunicative gaze. His other eye, the more dreamy left eye, perhaps the subdominant eye, is also looking at *you*, checking you out, making a bet: friend or competitor? Van Eyck signed the painting with a play on his name, "*Als Ich Can*," roughly meaning "As I Can," or, perhaps more colloquially, "This is my best shot. What's yours?"

Next, let's turn to another self-portrait from roughly the same period, Albrecht Dürer's self-portrait, dated 1500. What a difference in intent, pose, and effect! Dürer's self-portrait is not the more common three-quarter view of Van Eyck's self-portrait, a view predominant at the time, but instead is a straight-on, full-face view, a view that at

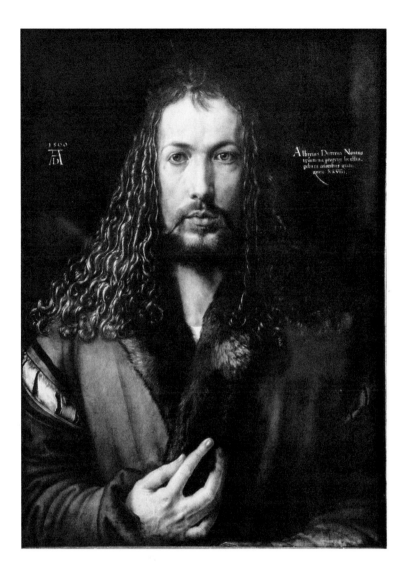

*Albrecht Dürer (1471–1528),
Self-Portrait (or Self-Portrait
at Twenty-Eight) (1500). Alte
Pinakothek, Munich, Germany.*

the time was reserved for portraits of saints or of Jesus.
The painting's Latin inscription translates as, *I, Albrecht
Dürer of Nuremberg, painted myself thus, with undying*[6] *col-
ors, at the age of twenty-eight.* Thomas Hoving, the often

[6] Undying meaning "permanent; nonfading."

opinionated, sometimes controversial former director of New York's Metropolitan Museum of Art, once called this painting "the single most arrogant, annoying, and gorgeous painting ever created."

Dürer faces the viewer directly, frontally, and intensely. The eyes and eyebrows are nearly symmetrical, but on close inspection, the artist's right eye seems slightly more dominant. The iris of the left eye is a bit smaller, the left eyebrow slightly forward, and the whole left eye somewhat subdued in shadow. Otherwise, the painting is largely symmetrical, except for the hand, placed centrally, as though delivering a blessing, but in an odd configuration of index and middle fingers. (If you try that hand position, you can feel the difficulty of the pose, which may have carried a coded message.) The rich, velvety brown cloak, trimmed in fur, reinforces the sensual but powerful message of Christlike aristocracy and spiritual power.

With these two Northern Renaissance self-portrait paintings by Jan van Eyck and Albrecht Dürer, a new category was added to artists' repertoire: portraits where the intervening person, the portrait artist, has been eliminated. The artist in a self-portrait can say, "Here I am. This is me." Dürer seems to add an unspoken demand, "I am looking at you. Pay attention!" And that category, the self-declarative portrait, is still vibrantly alive today.

SELFIES ARE THE NEW SELF-PORTRAITS OF OUR TIME

Down through the succeeding centuries, many, if not most, artists have drawn or painted self-portraits. Then came photography and many photographic self-portraits. And after that came "selfies," the current slang for self-portrait photographs. Today, we have the ubiquitous cell phone to create selfies galore and post them on the internet for all the world to see. The intervening person, the portrait artist, has long ago been eliminated, but now, also eliminated, are the time-consuming, skill-requiring rigors of actually painting or drawing a self-portrait. Today, without any artistic training whatsoever, each of us can be a photographic artist, able to produce our own self-portrait in multiples, with the luxury of choosing the one image out of dozens, or even hundreds, that shows us the way we want to be seen—the one that says, "Here I am. This is me."

What is it that we are seeking through selfies? I suspect that the answer to that question is that we are not seeking to influence how others see us but just the opposite: to see ourselves as we hope others see us. This brings to mind the words of Robert Burns, the great eighteenth-century poet and songwriter who said (in the original Scots language), *"O wad some Power the giftie gie us, to see ourselves as ithers see us!"* Or, in plain English, "Oh, would some Power the gift give us, to see ourselves as others see us."

The oldest known selfies are stencils of human hands in prehistoric cave painting sites, variously dated from 9,000 to 1,300 years ago. This is a photograph of "negative" hands from a prehistoric cave painting site: Cueva de las Manos (Cave of the Hands, Río Pinturas, Patagonia, Argentina, South America). The images are created by mouth-blowing charcoal dust or charcoal dust mixed with a liquid against one hand held against a stone wall, creating a negative-space hand painting.

Cave of the Hands, Patagonia, Province of Santa Cruz, Argentina

Here is a set of self-portraits by famous artists. I invite you to regard the images and ask yourself, "Why did this artist paint this self-portrait?" The answer may often seem to be another question from the artist to the viewer: "Do you see me the way I see myself?" And in the portraits, can you determine the dominant eye?

PORTRAITS AND SELF-PORTRAITS

On the fourth day of the five-day Drawing on the Right Side of the Brain workshops, our students draw a profile portrait of a fellow student and, on the fifth and last day, a self-portrait. These are challenging drawings. The profile drawing is challenging because, just as with a professional portrait artist, the student about to do the drawing surely must hope that the sitter, a fellow student (they take turns drawing each other), will approve of the drawing. And in

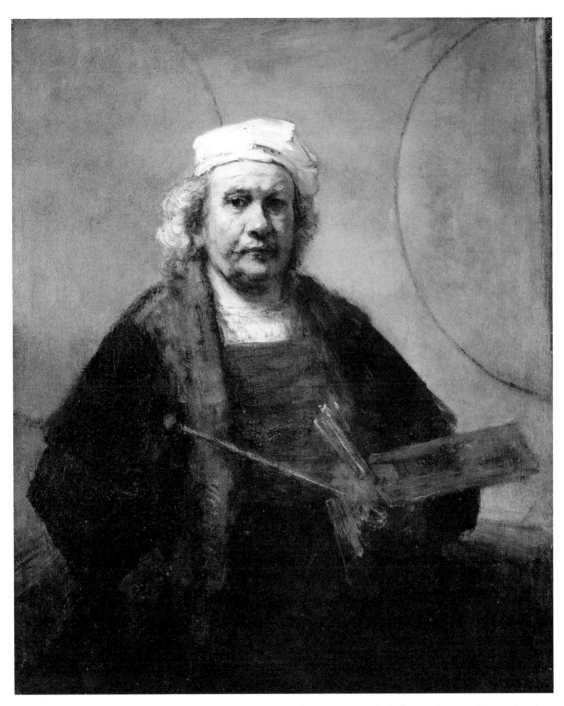

Rembrandt, Self-Portrait with Two Circles (c. 1665–1669). Collection Kenwood House, London. Photograph: English Heritage Photo Library.

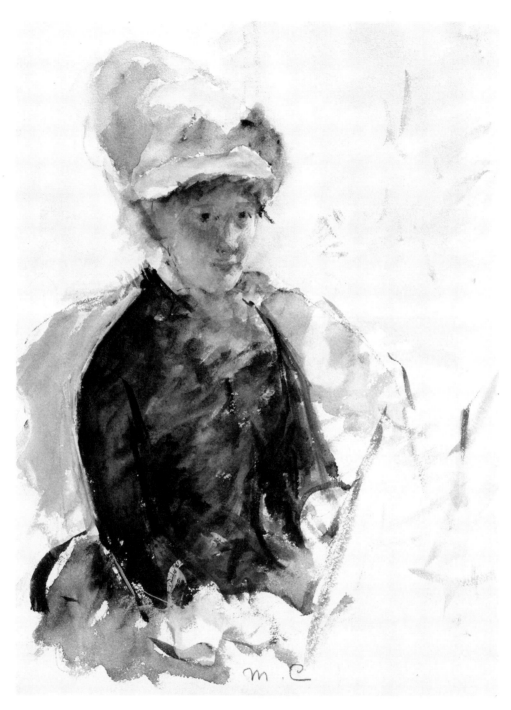

Mary Cassatt, Self-Portrait (c. 1880). National Portrait Gallery, Smithsonian Institution.

Frida Kahlo, Self-Portrait with Monkey (1938). © 2020 Banco de México Diego Rivera Frida Kahlo Museums Trust, Mexico, D.F. / Artists Rights Society (ARS), New York.

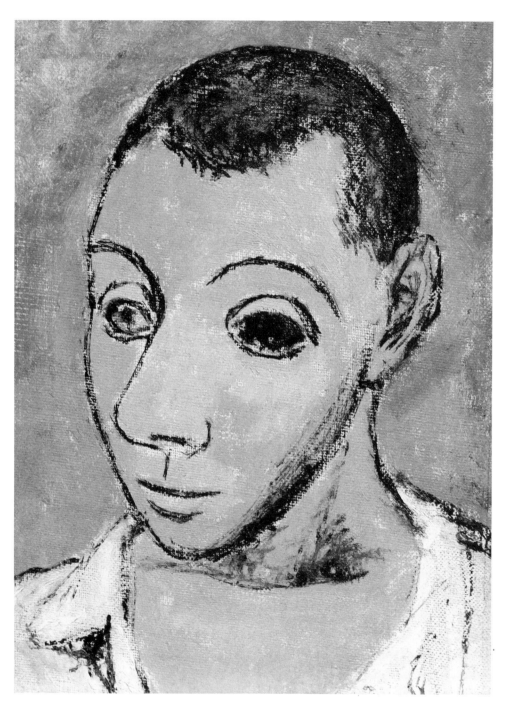

Pablo Picasso (1881–1973), Self-Portrait (1906). The Metropolitan Museum of Art, New York, Jacques and Natasha Gelman Collection, 1998. © 2020 Estate of Pablo Picasso / Artists Rights Society (ARS), New York.

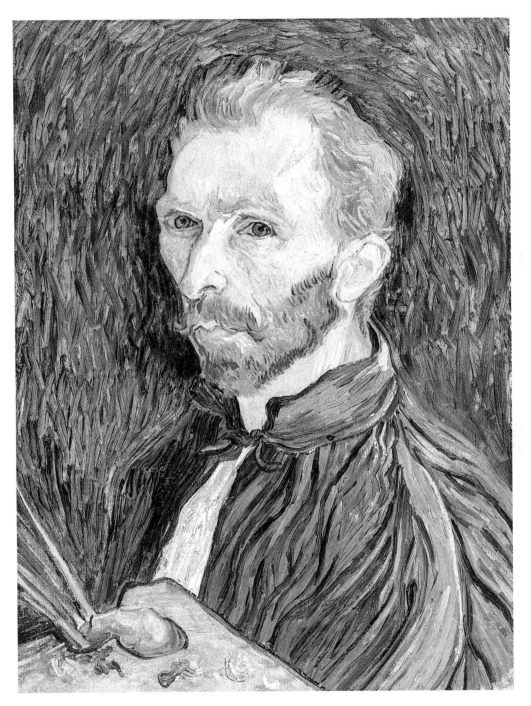

Vincent van Gogh (1853–1890), Self-Portrait (1889). National Gallery of Art, Washington, DC. Collection of Mr. and Mrs. John Hay Whitney.

"They say—and I am willing to believe it—that it is difficult to know yourself—but it isn't easy to paint yourself either." From a letter from Vincent van Gogh to his brother Theo, September 1889.

drawing the self-portrait, every student probably hopes that they can match the self-image with the reality of the mirror image in front of their eyes. This complicated process includes trying to balance vanity with realism, realism with acceptance, and at the same time, to try for excellence and beauty of the drawing as an art form. I am always amazed that our students meet this challenge with astonishing success.

To ask people who for the most part have been drawing for only four days to draw a self-portrait is, to put it mildly, an arduous assignment. But by focusing on the five skills of drawing outlined in Chapter One (edges, spaces, relationships, lights and shadows, and the gestalt), students are remarkably successful at self-portraiture. Their comments about their self-portraits are always interesting. One of the most frequent: "Before, I never really looked at myself in that way."

Left: Ana Mendes
Before instruction
April 16, 2018

Right: Ana Mendes
After instruction
April 20, 2018

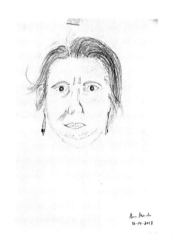
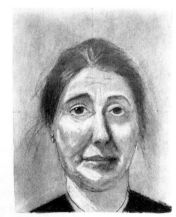

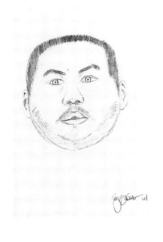

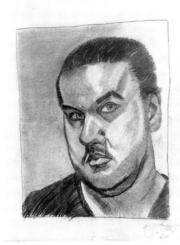

NORMAN ROCKWELL'S *TRIPLE SELF-PORTRAIT*

During the 1930s, '40s, '50s, and '60s, Norman Rockwell was America's favorite artist. People looked forward each week to his *Saturday Evening Post* cover paintings. Over his career, Rockwell painted 327 covers for the conservative weekly magazine. The 308th cover illustration, dated February 13, 1960, is one of the artist's most famous paintings, his so-called *Triple Self-Portrait*.

Until fairly recently, Norman Rockwell was never accepted by the fine art community as "one of us." His work was deemed too commercial, too trivial, too realistic, even too "skillfully painted." (Recall that Rockwell's active years were the heyday of American "action painting" and abstract expressionism.)

As far as we know, Rockwell cheerfully agreed with the fine art community's assessment. His term for himself was not "artist." It was "illustrator," or, later on, "genre

Norman Rockwell (1894–1978), Triple Self-Portrait (1960). Cover illustration for The Saturday Evening Post, *February 13, 1960. Printed by permission of the Norman Rockwell Family Agency. Copyright ©1960 the Norman Rockwell Family Entities.*

painter," meaning roughly "an artist of the people." The characters who filled his *Saturday Evening Post* covers were ordinary middle- or working-class Americans, frequently quite openly drawn by Rockwell from photographs. Rockwell's depictions usually leaned toward caricature— kindly caricature for the most part, and often amusing, but caricature, nevertheless. His magazine cover paintings transformed preparatory photographs into beautiful compositions, superbly drawn and painted, and all that skill was often poured into illustrating some mildly funny joke or sentimental moment.

But today, serious regard by the art establishment for Norman Rockwell's work is substantial and growing, possibly because of nostalgia for simpler times, but also because of solid admiration for his truly superb drawing, painting, and compositional skills.

A wonderful example of that skillfulness and the good-natured, broad humor suffusing Rockwell's work is his *Triple Self-Portrait* of February 13, 1960. It fits well with the subject of this book, and you can't help but love this painting, especially if you have ever tried to draw or paint your own self-portrait.

As the title states, there are three self-portraits in the painting.[7] The first is an image of the artist himself, sitting with his back to us, focused on the task at hand,

[7] Looking closely, you can see that the painting also includes a few postcards of notable artists' self-portraits, including those of Van Gogh and Rembrandt, which Rockwell tacked onto the easel.

and not caring or even conscious of how he looks to us or what we think of him. The second self-portrait is the image in the mirror, the "real" Norman Rockwell, looking a bit haggard and old, pipe sagging, eyeglasses fogged over by the effort to *see what to paint and how to fix up the image.* The third self-portrait is the underpainting on the large canvas that the artist is working on for the final product. He has already signed his name in the lower corner of the canvas, showing that he has committed to finishing this flattering image of himself. And that third portrait is the artist's idealized image of himself, clear-eyed, youthful, alert, and self-confident, with his pipe at a jaunty, carefree angle.

If you have ever drawn or painted a self-portrait, as so many of our students have done, you have experienced just what Norman Rockwell put into his painting. You have been torn between realism—drawing what you see—and idealism, drawing how you would prefer to be seen, and all the while, trying to create a successful drawing. Rockwell's *Triple Self-Portrait* is a wonderful depiction of that three-way challenge.

MINIMAL PORTRAITS: "Eye Miniatures"

A very odd and mysterious form of portraiture appeared for a short time in England and America, starting in 1785 and ending rather abruptly around the 1820s. The form was a very small portrait painting of a single eye of the person sitting for the "portrait." The paintings were

called "eye miniatures," and they were just that: tiny paintings, often on an ivory base, measuring only two or three inches wide at most and sometimes only an inch in length or width. On this minuscule base was painted a portrait composed of a single eye, usually the right eye but occasionally the left eye of the sitter for the "portrait," with a rare variation that portrayed both eyes. They are most often female eyes, but male eye miniatures were also fairly common. The single eye was usually shown with the eyebrow and eyelashes, and sometimes included a lock of hair or a bit of a nose but never enough to identify the person whose eye is the main subject. Toward the end of the 1790s, scores of European and British miniaturist artists came to America, where they found an eager patronage for the tiny eye portraits.

Portrait of a Right Eye (c. 1800). Philadelphia Museum of Art: Gift of Mrs. Charles Francis Griffith in memory of Dr. L. Webster Fox, 1936, 1936-6-3.

Portrait of a Woman's Right Eye (c. 1800). Philadelphia Museum of Art: Gift of Mrs. Charles Francis Griffith in memory of Dr. L. Webster Fox, 1936, 1936-6-8.

Portrait of a Woman's Right Eye (c. 1800). Philadelphia Museum of Art: Gift of Mrs. Charles Francis Griffith in memory of Dr. L. Webster Fox, 1936, 1936-6-8.

These hand-painted miniatures of single human eyes were usually set in jewelry frames and often given as mementos of love or mourning. In the true romantic tradition of the time, eye miniatures were often tokens of secret affairs, to be carried in a pocket or a purse as a

reminder of a loved one. Today, eye miniatures have been dubbed "lovers' eyes." In my view, that title conveys too frivolous a judgment of these tiny paintings. I regard them as a serious effort at a form of portraiture where the single eye, almost always featuring the dominant right eye but occasionally the left eye, reflects the normal distribution of eyedness. To me, the most interesting aspect of the eye miniatures is that a single eye is presented as standing for the whole person. The eyes as portrayed show little emotion, neither joy nor sadness. They seem to express, "I am here, thinking of you." Or, perhaps, "I am longing to see you."

Portrait of a Left Eye (c. 1800). Hope Carson Randolph, John B. Carson, and Anna Hampton Carson in memory of their mother, Mrs. Hampton L. Carson, 1935, 1935-17-14.

Portrait of a Left Eye. Philadelphia Museum of Art: Gift of Joseph Carson, Hope Carson Randolph, John B. Carson, and Anna Hampton Carson in memory of their mother, Mrs. Hampton L. Carson, 1935, 1935-17-14.

The eye miniatures are almost startlingly realistic and have a strangely hypnotic effect. The miniaturist painters who did the work were exceedingly skilled, and the paintings have an almost obsessive quality about them.

AN EXERCISE IN DRAWING AN EYE MINIATURE AS SELF-PORTRAITURE

As an experiment, I thought that perhaps you, the reader, might take a first step in self-portraiture by making an eye-miniature drawing of your own. The materials required are minimal: a sheet of fairly heavy drawing paper or lightweight cardboard, a 2B or 4B drawing pencil (and/or colored pencils if you prefer), and an eraser such as a Pink Pearl or a white plastic eraser—all available in most craft stores or by mail or online from art supply stores. A small protractor for drawing circles would be helpful but not essential.

The first step is to draw a framing outline on the heavy paper or lightweight cardboard. Your frame can be round, oval, square, or rectangular; whichever you choose. The largest dimension should probably be about 2½" by about 3½", but it's your choice. A round frame can be a line traced around a small water glass or wineglass of suitable size.

An oval frame can be roughly but simply achieved as follows:

1. Use a ruler or straight edge to draw on your paper a straight horizontal line about 4 inches long.

2. On the line, place two dots with your pencil, about 1¼ inches apart.

3. Find a small glass or bottle cap about 1⅓ inches in diameter, or use a protractor.

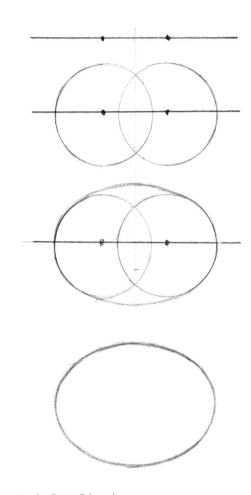

Drawing by Betty Edwards

4. Center the small glass, bottle cap, or protractor over one of the dots on the line. Use your pencil to draw a line halfway around the glass on the right side (see diagram).

5. Center the glass over the other dot and draw halfway around on the left side.

6. Freehand and by eye, connect the two half circles to make an oval frame.

The next step is to decide, using a handheld mirror, which eye, right or left, to use as the model for your eye miniature. Significantly, and probably to be expected, nearly everyone chooses the dominant eye, whether right or left, which I believe is also true of the early eye miniatures, as most of the miniatures are of the sitter's right eye. I am not sure why this is the case, but intuitively, it is what I did in trying out this exercise. Somehow, it would not feel right to draw the subdominant eye.

Once decided, you can begin to draw. Here are some suggestions for proceeding:

1. Looking at your eye in a mirror, draw the shape made by the white of the eye. In other words, don't draw the edge of the upper and lower lids: draw the shape of the visible eyeball as a negative space.[8] This will give you the correct curves of the edges of the lids.

2. Draw the shape of the white of the eye surrounding the iris as a negative shape. This will inadvertently give you the shape and position of the iris.

3. Draw the shape of the colored part of the iris. This will give you the shape and position of the pupil, which is centered in the iris.

4. To draw the crease of the upper lid, draw the shape between the crease and the edge of the upper lid.

5. To draw the eyebrow, draw the shape of the space between the crease of the upper lid and the eyebrow.

Drawing by Betty Edwards

6. Complete the drawing by adding the details of eyelashes, eyebrow, inner corner of the eye, etc.

[8] See Chapter Five to review instructions for negative space.

Observe that eyelashes grow *down* from the upper eyelid and then (usually, but not always) curve up—an important detail. And the lower eyelashes grow *up* from the lower lid and (usually) then curve downward. This detail softens the edges of the eyelids.

Also observe that, depending on the light source for your drawing, there may be a tiny highlight on the iris/pupil of the eye. This is an important detail that you can observe in the examples provided of eye miniatures. You can plan ahead and leave the small highlight to be the white of the paper by drawing around it as you draw the iris and pupil, or you can erase it after the fact by breaking off a piece of your eraser, sharpening it to a point with a small knife or razor blade, and carefully erasing the tiny highlight. Complete the drawing by adding whatever

Drawing by Brain Bomeisler

details or "shading" that you feel will finish the drawing, or possibly a frame around it.

Congratulations on completing your own "eye miniature" drawing! It is not a total self-portrait, but it is your "look," your "gaze," and, in a compelling way, your identity. I'm sure you see that it is a quite mesmerizing image. As author Hanneke Grootenboer wrote about eye miniatures in her 2012 book on the subject, *Treasuring the Gaze: Intimate Vision in Late Eighteenth-Century Eye Miniatures*, "They articulate the essence of portraiture; the act of looking *at* you, the ability of a painting to hold you in its grip."

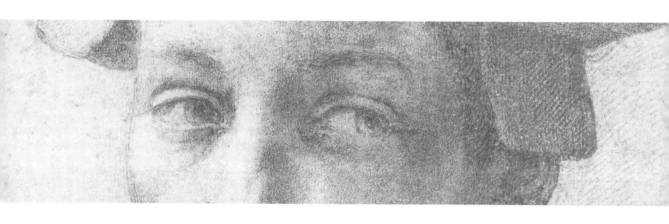

Michelangelo Buonarroti, Portrait of Andrea Quaratesi (1532).
Collection, The British Museum. © Trustees of the British Museum.

Drawing Some Conclusions

*D*rawing on the Right Side of the Brain is about self-discovery—how drawing can help open up that part of the mind that in our schools has been increasingly subordinated to a mainly verbal, digital, left-brained world. This book extends such self-discovery to include the difference between our two eyes and how that difference relates to the art of seeing and drawing.

Clearly, one key to unlocking access to the visual, perceptual, relational right-brain hemisphere is Art in general and in all its variations: the visual arts (painting, drawing, sculpture, and photography), musical arts (including dance), performance arts, and literary arts. My lifelong personal focus has been on teaching the visual arts in general and especially teaching drawing. A key part of that specialization is portraiture and self-portraiture, and in teaching those subjects, I more or less stumbled on an important individualizing characteristic that is the subject of this book: eye dominance, or "eyedness." To my surprise, I found that this is a somewhat unfamiliar personal characteristic—shared by all of us but little known, except for a few specialized groups that I described in Chapter Two: archery fans, target shooters, and practitioners of other "aiming" sports, as well as a fairly limited number of scientific groups who have been actively researching eye dominance since around the year 2000.

EYE DOMINANCE AND MEANING

The eyes are a key feature—perhaps *the* key feature—in portraiture. As I have explored in previous chapters, the effect and meaning of a portrait often depends on eye expression. The close observation required for a portrait or self-portrait inadvertently reveals the sitter's eye dominance and sub-dominance. In viewing portraits and self-portraits throughout this book, a question likely arises: What, if anything, does eye dominance *mean* in terms of the personality and mental traits of the sitter? Can eye dominance be read as something that conveys *meaning*?

A look at *handedness* might indicate something about this question and a possible answer, even though handedness, unlike eyedness, is usually not evident in portraits. But both are outward signs of differences between the left- and right-brain hemispheres and how a person's brain is organized. Scientists have done a great deal of research on handedness and what it means in terms of personality and mental traits.

As casual observers, most of us sense that handedness, especially left-handedness, means *something*. And though we are not sure what that something is, assumptions—mostly negative assumptions—have been rampant down through countless centuries. For example, the Latin term for the left hand, still used in medical practice today, is *sinistra*, which translates to "sinister" (as in evil or bad), while the Latin term for the right hand, *dexter*, evolved to the positive word "dexterous" (meaning adroit or skillful).

Also, in the past, parents and teachers have coerced left-handed children to change their natural handedness to the more socially approved right-handedness. Today, fortunately, these attitudes have mostly disappeared.

There has been no similar disapproval of left-eyedness, possibly because left-eyedness is not so clearly noticeable. Another possibility is that left-eyedness is more common. Recall the percentages in the population: 90 percent right-handers to 10 percent left-handers; for eyedness, 65 percent right-eyed to 34 percent left-eyed, with 1 percent being equal-eyed.

Characteristics of Left-Handers

Left-handedness has been a subject of scientific study for decades. What conclusions have researchers reached about characteristic traits of left-handers? Briefly stated, left-handers in general are judged to be quick thinkers who can intuit creative connections between unlike things or ideas. They are better at some sports, such as boxing, tennis, and golf. And they excel at divergent thinking, meaning that they often can produce multiple solutions to questions or problems. That is the good news. (There is always "good news" and "bad news" in these descriptions.) The bad news about left-handers is that they may find it difficult to plan a project and work step-by-step to a conclusion because, along the way, new ideas and better solutions divert them from the step-by-step work, and they may find it difficult to settle on a conclusion.

Right-Handed and Right-Eyed People

What about the larger percentage of us, who are right-handed and right-eyed? This group may experience greater mental agreement between what is said and what is seen. I am guessing that right-handed, right-eyed people are good at planning and taking pre-planned steps to a conclusion and, while in process, may be able to resist distractions and unexpected new ideas until a conclusion is reached. But this may result in unplanned surprises, embodied in the classic challenge "Couldn't you see what was going on?" Again, future research may enlighten us on the effects of this brain organization, both the good news and the bad. I suspect that there may be the possibility of too much agreement between the hemispheres and too little attention paid to incoming new data or alternative steps to a conclusion.

Right-Handed and Left-Eyed People
(Mixed Dominance)

I also wonder what the effect of eyedness is for someone who is right-handed and left-eye dominant. Again, I suspect that this is a good-news, bad-news situation. The good news may be that a right-handed person with clearly evident left-eye dominance might have a good check on reality and can *see* the best path forward. The right hemisphere/left eye are there, watching the left hemisphere do its verbal spinning, often including, let's face it, pre-planned expectations and exaggerations possibly

expanding to untruths, and leaving the dominant left eye to express its nonverbal disagreement and disapproval, perhaps with a lowered eyebrow and an annoyed expression. The question here is whether the powerful left brain will respond to its nonverbal visual partner.

The Unusual Cases of Left-Handers Who Are Left-Eye Dominant

Left-handers who are left-eye dominant are rare humans. My guess is that researchers planning a study of this group would have difficulty even locating enough individuals for a study group. My limited understanding will only allow a guess that such a group would be not only highly creative but might also operate in an arena of highly advanced thinking, not necessarily tied to verbal logic or rationality, such as mathematics or quantum physics. Or, as a downside, this may be a configuration that is not easily adaptable to ordinary modern life.

Speaking of Mixed Dominance: The Marx Brothers

All this brings to mind images of the Marx Brothers, stars in comic movies from the 1930s to the 1950s. The brothers could be a possible metaphor for the left and right sides of the brain. Groucho would represent the left brain: he was always talking, a know-it-all making plays on words, highly competitive, and prone to stretching the truth. Harpo is a perfect metaphor for the right hemisphere:

The Marx Brothers: Harpo,
Chico, and Groucho, 1930s

cheerful and good-natured but mute—unable to put any-thing into words. He would beep a little horn or whistle to stay in the conversation. But Harpo was the one who most often came up with visually acted-out, wordless, *real* solutions to the unending problems encountered by the Marx Brothers.

The third brother, Chico, was a kind of shrewd observer and bridge between Groucho and Harpo. He was also a real conniver and a great con artist with a gift for gab, always on the lookout for a way to win. Chico's famous line, so suitable for this discussion, was: "Who you gonna believe, me or your lying eyes?"

There were actually five Marx Brothers. Gummo left the brothers' vaudeville act in 1918 to join the army, and Zeppo also left the act at a later date. The popular films of the 1930s and '40s featured Groucho, Harpo, Chico, and Zeppo.

A survey conducted on the internet* by an all-male group for "The woman with the most beautiful eyes" had as a specific requirement that her eyes be perfectly symmetrical, suggesting that the real search was for the most compliant woman.

* "Are These the Most Beautiful Faces in the World?" *The Telegraph*, March 30, 2015, https://www. telegraph.co.uk/news/11502572/ Are-these-the-most-beautiful-faces -in-the-world.html.

Symmetrical Eyes

Last, we arrive at the unusual circumstance of symmetrical eyes, a rare trait where neither eye is dominant, true of only 1 percent of adult human beings. Symmetrical eyes have been described in a positive way as "open, innocent, trusting, believing and believable, guileless." As a possibly lone dissenter, I find symmetrical eyes somehow a bit *scary*. I sense that the reality check is missing, that the left hemisphere has overwhelmed and convinced the right brain that its left-brain perceptions and verbal convictions are the correct and only ones acceptable. Or, conversely, that the visual, perceptual right hemisphere has convinced the left brain not to try a verbal check and rationale for what it sees as reality. There is perhaps no longer an argument from either hemisphere, and no reality check by the left eye/right brain. The right brain has perhaps capitulated to Chico Marx's demand, "Who you gonna believe, me or your lying eyes?"

SUMMING UP

What does all this mean for those of us who are just trying to read faces for meaning? It provides a slight advantage, I believe. Alerted to variations in eye dominance, we can first of all seek to identify and address the dominant eye in conversation. A second advantage may be that knowing the varying patterns of dominance and subdominance could possibly provide at least *some* insight into another

person's true self if the relationship is more than just a casual meeting.

Eye dominance does become more noticeable with age, and this makes reading mature faces somewhat easier than reading faces of the very young. Eyebrow positioning (with eyebrows either pulled closer to the center line of the face and/or pulled back from the center line) will help guide you to a person's dominant eye, and this guidance increases with age. Eyelids may become more widened or narrowed, and wrinkles may deepen between the eyebrows to become markers—almost like arrows—pointing toward the dominant eye.

LEONARDO'S "ANGEL"

An excellent example from art history of a clearly dominant eye is Leonardo da Vinci's extraordinary preparatory drawing of the "Angel" for his painting *The Virgin of the Rocks*.

The drawing is reproduced on the cover of the 2012 edition of *Drawing on the Right Side of the Brain*. At the time, I was not thinking about eye dominance when I chose the drawing for the book cover. I had loved the drawing from the moment I first saw it as a young art student, but I had always been slightly puzzled about the difference between the Angel's eyes. The near eye (the Angel's left eye) is so meltingly soft in its gentle dreaminess, while the eye on the left (the Angel's right eye) is a bit more harshly drawn

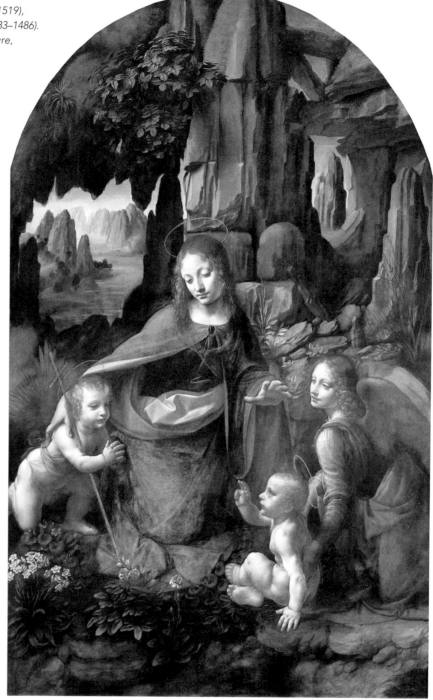

Leonardo da Vinci (1452–1519),
The Virgin of the Rocks *(1483–1486).*
Collection Musée du Louvre,
Paris.

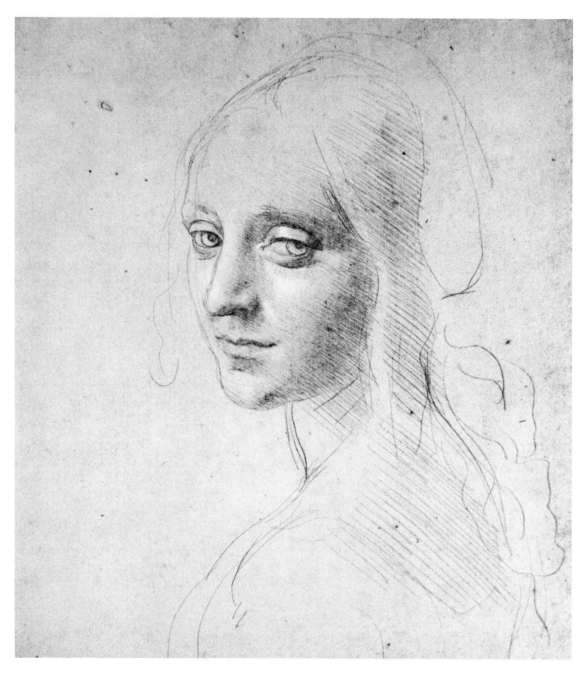

Art historian Sir Kenneth Clark said of this drawing, "One of the most beautiful, I dare say, of all the drawings in the world."

Leonardo da Vinci, Head of a Girl, also known as
Angel: Study for The Virgin of the Rocks *(1483–1485). Biblioteca Reale, Torino.*

and gazes directly at you and at me, the viewers, with a more alert, direct expression. I realize now that Leonardo intuitively saw and drew the Angel's right eye as the dominant eye: not soft and tender to match the Angel's left eye, but alert and even challenging, thus portraying the Angel as a multidimensional and complex being.

A FINAL DRAWING EXERCISE

For the last chapter of this book, I thought it would be appropriate to use Leonardo's extraordinary work for an exercise. We will be using one of the world's most famous and beloved drawings as a model for an unlikely exercise that could be viewed as disrespectful to one of the greatest drawings in all of art history.

But never mind. Let's just do it.

You will be drawing only the Angel's eyes. As you see, I have cut a narrow slice of the drawing to show just the eyes. The image is upside down. If you can resist, do *not* turn the book to see the image right-side up.

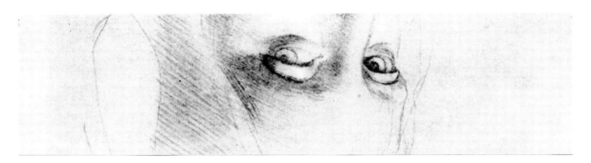

Drawing by Brian Bomeisler

1. On a plain sheet of paper, placed vertically, use a ruler or straight edge to lightly draw two lines all the way across the paper, exactly 1¾ inches apart.

2. About a half inch from each edge of the paper, draw the ends of the rectangle. This is your format—the frame for your drawing.

3. Without turning the image right-side up, note where the edge of the Angel's cheek intersects with the upper edge of the format (a bit more than one-third of the upper edge). Draw the edge of the cheek and forehead.

4. Draw the shape under the eye on the right and between the edge of the cheek and the edge of the nose.

5. Draw the edge of the nose. Note the angle of the edge of the nose and the curve under the eye.

6. Draw the shape of the upper and lower lids of the eye on the right.

7. Look at the shape of the white of the eye and draw that shape, which will also give you the shape of the iris of that eye.

8. Look at the shape of the iris and draw the pupil of the eye. Remember to leave the tiny highlight in the pupil: the white of the paper.

9. Draw the edges of the upper and lower creases of the eyelids.

10. Next, carefully estimate the distance to the inside corner of the Angel's other eye compared to the width of the first eye drawn. (It is slightly less than 1:1.)

11. Compare the width of the eye on the right to the width of the eye on the left. It is about 1:1⅓. Note the angle of the eyes: a line through the inside corner of both eyes will slope downward to the right.

12. Draw the second eye: first, the shape between the lids as a negative space. (Note that a line drawn through the inside to the outside corners of the eye on the left is horizontal.) Next, see and draw the negative space of the white of the eye. This will give you the outside edge of the iris. Then draw the shape of the iris, then the pupil. Don't forget to leave the tiny highlight.

13. Next, draw the shape of the upper eyelid by drawing the crease of the lid, and then draw the slight crease under the lower lid.

14. Finally, shadow in the shape above and around the eye and down the side of the nose. Use your pencil to lightly crosshatch the shadows and then rub lightly with your finger or a bit of tissue.

15. Observe the hatched area to the left of the eyes. This is difficult for most right-handers to copy. Leonardo was left-handed and the hatchings go the "wrong direction" for right-handers. You might try turning the drawing to make it easier for right-handed hatching if you are, in fact, right-handed.

Last, turn your drawing right-side up. Congratulations on completing this final exercise in drawing! You have re-created the most important part of one of the most beautiful drawings in the world, Leonardo da Vinci's "Angel."

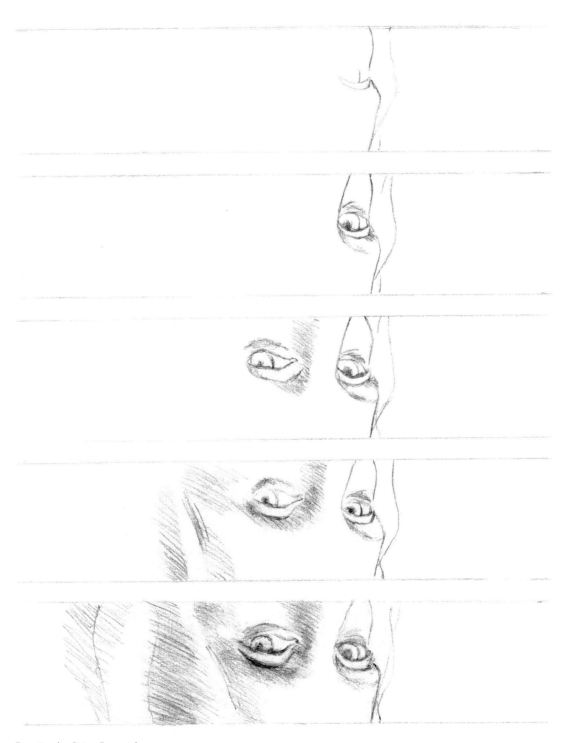

If there are some slight wobbles in your drawing, remember that you were working from a drawing by one of the world's greatest artists. If your drawing comes even a fraction of the way near to the original, that is an achievement.

TO CONCLUDE

Future research may or may not determine links of eye dominance to personal traits and ways of thinking. As I have noted, left-handedness has been observed and studied for centuries without any real agreement on its meaning. Nevertheless, I believe that awareness of eye dominance is of personal value to individuals and may have a positive effect in terms of personal relationships. Certainly, sensitivity to differences in eyedness is enormously helpful in viewing, understanding, and drawing portraits and self-portraits.

The possible long-term effects of learning to draw during the years of childhood education remain largely unknown and untried, and unfortunately, the arts are gradually disappearing from public schools, so we may never know. Drawing in particular is avoided in favor of less rigorous art activities, often referred to as "manipulation of materials" in educational journals.

Yet all young children draw, most often developing delightfully unique sets of symbols to illustrate their ideas, reminding us of the evident passion of our prehistoric ancestors for portraying their perceptions by way of drawings. You may yourself remember certain early

drawings of your own childhood. Problems start around age eight or nine, when children outgrow their early symbolic drawings and want to make things "look real." Given good instruction, children at this age can indeed learn to draw well, and drawing can be infused into other subjects, making those subjects more visual, more interesting, and, especially important, *more memorable* by bringing both hemispheres to bear on learning. If children's passion for realism in drawing is not fulfilled with appropriate instruction, they will give up on drawing forever and become those adults who proclaim that they "can't draw a lick," or that they "have no talent for drawing."

Fortunately, however, drawing can be learned at any age and under almost any circumstances. The requirements are few: no special equipment, no special physical fitness requirements, no age limitations. The materials needed are simple: some paper, a pencil, and an eraser. The exercises in this book are only a start on what can become a lifelong interest in drawing what you see with your own two eyes.[9] In time, your drawings will reveal you to yourself—your specific style of drawing, your particular choice of subjects for drawing, your two minds made visible to you and to others.

One of the most valuable benefits of learning to draw is the restorative effect of the time spent engaged in

[9] See *Drawing on the Right Side of the Brain*, TarcherPerigree, 2012, for more extensive drawing instructions and exercises.

drawing. Once you have shifted to the "drawing" state of mind, the verbal brain hemisphere will be quiet while you draw. When the drawing is finished, you will return to your usual verbal state of mind refreshed and rested.

This is one of the great gifts of drawing, along with becoming aware of the value of *seeing* rather than "just looking." But there are other important gifts. Learning to draw can bring the attention of the dominant eye and the dominant left hemisphere to the importance of the right hemisphere's ability to "see what is going on," and to successfully communicate its wordless, visual perceptions to the verbal brain.

The title of this book, therefore, has a double meaning. First, I am asking you, the reader, to "draw on your dominant eye" for its great ability to link to words and monitor verbal communication. But second, I am also asking you, the reader, to draw on your dominant eye to encourage and enable your nonverbal, visual right hemisphere to partner in thinking and problem solving. This means acquiring some control over your own brain, which, fortuitously, is a side benefit of learning to draw. This reminds me of times past when I presented lectures on "right brain/left brain," occasionally to fairly large audiences. Sometimes I would make the joke, "Part of learning to draw is learning to control one's own brain, but my own brain, sad to say, is often out of control." This statement, without fail, would trigger a wave of rueful laughter in the audience, which I

took to mean that their brains, too, were sometimes out of control.

I thought then, and I still think today, that for most of us it is true: our brains are sometimes out of control. This idea brings to mind another idea, that each of us needs to take charge of our own brain and bring it under better control. Learning to draw requires that the left hemisphere processes verbal instruction, and then deliberately sets the words aside to enter that wordless, timeless, right-hemisphere state of drawing. This state is highly pleasurable and certainly stress-reducing. I think it is possible that the verbal left hemisphere worries that if you get "over there" long enough, you won't come back. This is nothing to worry about. The right-hemisphere state of drawing is extremely fragile. It ends when someone asks, "How is the drawing going?" . . . or when your timer goes off.

My hope is that you will embark on this experimental voyage of drawing on your dominant eye/brain to engage with your subdominant eye/brain, even if it is just out of curiosity to see what happens. One thing I know for certain from my long experience in teaching drawing: Just as learning to read never harms but always helps, learning to draw never harms. It always helps.

According to his biographer Giorgio Vasari, Michelangelo was most reluctant to make portrait drawings "unless the subject was one of perfect beauty," and this is the only surviving portrait drawing by Michelangelo. Drawn in black chalk in 1532, it shows the head and shoulders of a young man, Andrea Quaratesi (1512–1585), who was one of several noble youths much admired by Michelangelo. Though from an aristocratic Florentine family, it is possible that Michelangelo tried to teach this young man how to draw, as the artist wrote on a drawing now in Oxford: "Andrea, have patience." The young man wears contemporary dress, a cap flat on his head, as he looks out to his left. The drawing is lit so that the delicate shadows are formed by small, careful, parallel strokes of chalk.

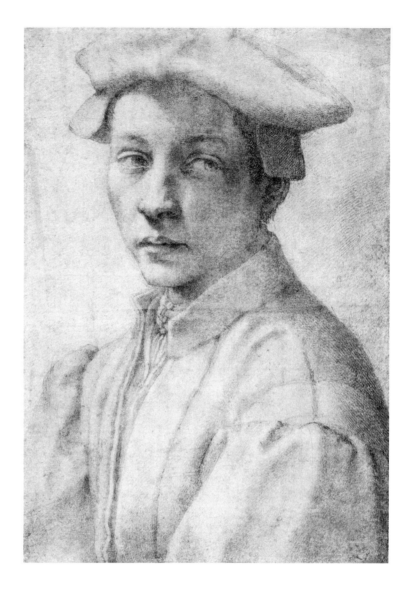

Michelangelo Buonarroti, Portrait of Andrea Quaratesi *(1532).*
Collection, The British Museum.
© Trustees of the British Museum.

GLOSSARY

ABSTRACT ART. A nonrealistic translation of a real-life object or experience into a drawing, painting, sculpture, or design. Abstract art may have some realistic elements.

CENTRAL AXIS. Human features are more or less symmetrical and are bisected by an imaginary vertical line approximately in the middle of the face. This line is called the central axis. It is used in drawing to determine the tilt of the head and to place the features.

CEREBRAL CORTEX. The outermost part of the cerebrum, consisting of the two cerebral hemispheres clearly separated into the right and left sides of the brain. The hemispheres are partially connected to each other by a thick band of nerve fibers called the corpus callosum.

CEREBRUM. The main division of the brain in vertebrates, consisting of two hemispheres. Consists essentially of the cerebral cortex, corpus callosum, basal ganglia, and limbic system. It is the last part of the brain to evolve and is of critical importance in all kinds of mental activity.

COGNITIVE SHIFT. A change in mental processing, e.g., from verbal to visual mode or visual to verbal mode, or to a combination of both modes.

COMPOSITION. An ordered relationship among the parts or elements of a work of art. In drawing and painting, the arrangement of forms and spaces within the format.

CONCEPTUAL IMAGES. Imagery from internal sources (the "mind's eye") rather than from external, perceived sources.

CONTOUR LINE. In drawing, a line that represents the shared edges of a form, a group of forms, or positive forms and negative spaces.

CORPUS CALLOSUM. A compact bundle of axons connecting the right and left cerebral cortices. The corpus callosum allows the two halves, or hemispheres, of the cerebral cortex to communicate directly with each other.

CREATIVITY. The ability to find new solutions to problems or new modes of expressing ideas; to find hidden patterns; to connect unrelated things or ideas; to bring into existence something new to the individual and to the culture. Writer Arthur Koestler added the requirement that the new creation should be socially useful.

CROSSHATCHING. A series of intersecting sets of parallel lines used to indicate shading or volume in a drawing. Many artists develop individual styles of hatching, which becomes a "signature."

DOMINANT EYE AND SUBDOMINANT EYE. The tendency to prefer input from one eye rather than the other, which is sometimes called "eyedness." Eye dominance is somewhat analogous to handedness, but the side of the dominant hand and the dominant eye do not always match, and each eye takes charge of a different half of the field of vision. The dominant eye has more neural connections to the brain than the subdominant eye. The dominant eye is used in sighting. Approximately 65 percent of humans are right-eye

dominant, 34 percent are left-eye dominant, and 1 percent are equal-eye dominant.

EDGE. In drawing, edges are *shared* edges: the place where two things meet. For example, the *single* line of separation between two shapes or a space and a shape, which becomes, in essence, a connecting edge. This concept leads to a sense of *unity* in artworks.

EXPRESSIVE QUALITY. The individual differences of the way each of us perceives and represents our perceptions in a work of art. These differences express an individual's inner reactions to the perceived stimulus as well as the unique "touch" arising from individual physiological motor differences.

EYE LEVEL. In perspective drawing, a horizontal line on which parallel lines above and below it appear to converge. In portrait drawing, the proportional line that divides the head approximately in half horizontally; the approximate location of the eyes is at this halfway mark on the head.

FORESHORTENING. A way to portray forms on a two-dimensional surface so that they appear to advance or recede in space on a flat surface; a means of creating the illusion of three-dimensional spatial depth in figures or forms.

FORMAT. The outside shape of a drawing or painting surface—usually rectangular or square; rarely circular or triangular. The proportion of the surface; that is, the relationship of the length to the width of drawing paper or of canvas for painting. Also, a drawn line that defines the two vertical and two horizontal edges of an artwork.

GESTALT. An organized whole that is perceived as more than the sum of its parts.

HEMISPHERIC LATERALIZATION. The differentiation of the two cerebral hemispheres with respect to function and mode of cognition.

IMAGE. *Verb*: to call up in the mind a mental "picture" of something not present to the senses; to see in the "mind's eye." *Noun*: a retinal image; the optical image of objects actually seen with the eyes and interpreted by the brain.

IMAGINATION. The ability to mentally form new ideas, images, or concepts about external objects not physically present.

INTUITION. Direct and apparently unmediated knowledge; a judgment, meaning, or idea that occurs to a person without any known process of reflective thinking. An intuition is often reached as a result of minimal cues and seems to "come from nowhere."

LEARNING. Any relatively permanent change in thinking or behavior because of cognition, experience, or practice.

LEFT HEMISPHERE. The left half (oriented to your left side) of the cerebrum. For most right-handed individuals (90 percent of them) and a portion of left-handed individuals (10 percent), verbal functions are primarily located in the left hemisphere.

LINEAR PERSPECTIVE. Linear perspective is an approximate representation, generally on a flat surface such as paper, of an image as it is seen by the eye. Objects appear to

become smaller as their distance increases from the observer, and objects appear shorter (foreshortened) along the line of sight. Angles relative to vertical and horizontal appear to change depending on the viewer's position.

NEGATIVE SPACES. The areas around positive forms that share edges with the forms. Negative spaces and positive forms are bounded by the outer edges of the format. "Interior" negative spaces can be part of positive forms; for example, in portrait drawing, the whites of the eyes can be regarded as interior negative spaces useful for correctly positioning the irises.

OCULAR DOMINANCE. Sometimes called "eye preference" or "eyedness." Most people have a tendency to prefer visual input from one eye, either the left eye or the right eye, and this tendency is visually detectable by one person observing another. Eyedness is somewhat analogous to handedness, but the side of the dominant eye and the dominant hand do not always match, a benign condition called "cross dominance." The dominant eye has more neural connections to the brain than the subdominant eye. Both hemispheres control both eyes, but each hemisphere takes charge of a different half of the field of vision and therefore a different half of both retinas. Approximately 65 percent of the world population is right-eye dominant, 34 percent left-eye dominant, and 1 percent neither-eye dominant.

PERCEPTION. The awareness, or the process of becoming aware, of objects, relationships, or qualities—either internal or external to the individual—by means of the senses and under the influence of previous or new experiences.

PICTURE PLANE. An imaginary construct of a transparent plane, like a framed window, that always remains parallel to the vertical plane of the artist's face. The artist draws on paper or paints on canvas what the artist sees through and beyond the plane as though the view were flattened on the back of the transparent plane. Inventors of photography used this concept to develop the first cameras.

REALISTIC ART. The objective depiction of real objects, forms, and figures attentively perceived. Also called "naturalism."

RIGHT HEMISPHERE. The right half (oriented to your right side) of the cerebrum. For most right-handed individuals and a large proportion of left-handed individuals, visual, spatial, relational functions are located mainly in the right hemisphere.

SCANNING. In drawing, the practice of checking or estimating points, distances, or degrees of angles relative to the constants, vertical or horizontal, or sizes relative to a "starting shape."

SIGHTING. In drawing, measuring relative sizes by means of a constant measure, often the part drawn first (the "starting shape"). Determining relative sizes in a drawing or the location of one part relative to some other part. Also, determining angles relative to the constants vertical and horizontal, which are represented by the vertical and horizontal edges of the format.

SPLIT-BRAIN PATIENTS. During the late 1950s and early 1960s, individuals who had been suffering from intractable epileptic seizures and whose medical problems were relieved by a surgical operation separating the two hemispheres by severing the connecting organ, the corpus callosum. The procedure,

technically termed "commissurotomy," has been rarely used, and "split-brain" patients (a term mainly used by reporters and researchers) were few in number. Subsequent Nobel Prize–winning research by Roger Sperry and his colleagues at the California Institute of Technology yielded valuable insights into human brain-hemisphere functions.

STARTING SHAPE OR STARTING UNIT. An edge or shape chosen from within a composition for the purpose of maintaining correct size relationships in a drawing. The starting shape is always termed "one" and becomes part of a ratio, as in 1:2, 1:3, or 1:4½, etc., in order to determine relative sizes within a composition.

SYMBOL SYSTEMS. In childhood drawing, sets of symbols, often unique to each child, are consistently used together to form an image—for example, a human face or figure or house. The symbols are usually produced in sequence, one appearing to call forth the next, much in the manner of writing familiar words, in which writing one letter leads to writing the next. Symbol systems are usually set in childhood and often persist throughout adulthood unless modified by learning new ways to see and draw, ideally around ages eight to ten.

VALUE. In art, the darkness or lightness of tones or colors. In art terms, white is the lightest value; black is the darkest value.

VISUAL INFORMATION PROCESSING. The use of the visual system to gain information from external sources and the interpretation of that visual data by means of cognition.

BIBLIOGRAPHY

Bakker, N., Jansen, L., and Luijten, H. *Vincent van Gogh—The Letters: The Complete Illustrated and Annotated Edition*. London: Thames & Hudson, 2009.

Bambach, C. *Michelangelo: Divine Draftsman and Designer*. New York: Metropolitan Museum of Art, 2017.

Bogart, A., "The Power of Sustained Attention or The Difference Between Looking and Seeing," *SITI Company*, December 17, 2009. http://siti.org/content/power-sustained-attention-or-difference -between-looking-and-seeing

Carbon, C-C., "Universal Principles of Depicting Oneself Across the Centuries: From Renaissance Self-Portraits to Selfie-Photographs," *Frontiers in Psychology*, February 21, 2017. Lausanne, Switzerland.

Dobrzynski, J.H., "Staring Dürer in the Face," *The Wall Street Journal*, March 15, 2008.

Dodgson, C.L. [pseud. Carroll, L.] *The Complete Works of Lewis Carroll*, edited by A. Woollcott. New York: Modern Library, 1936.

Edwards, B. *Drawing on the Right Side of the Brain*. New York: TarcherPerigee, 4th ed., 2012.

———. *Drawing on the Artist Within*. New York: Simon & Schuster/ Touchstone, 1987.

Green, E.L., and D. Goldstein, "Reading Scores on National Exam Decline in Half the States." *The New York Times*, October 30, 2019.

Gregory, R.L. *Eye and Brain: The Psychology of Seeing*. 2nd ed., rev. New York: McGraw-Hill, 1973.

Grootenboer, H. *Treasuring the Gaze: Intimate Vision in Late Eighteenth-Century Eye Miniatures*. Chicago: The University of Chicago Press, 2014.

Henri, R. *The Art Spirit: Notes, Articles, Fragments of Letters and Talks to Students, Bearing on the Concept and Technique of Picture Making, The Study of Art Generally, and on Appreciation.* Philadelphia and London: J.B. Lippincott Company, 1923.

Hoving, T. *Greatest Works of Art in Western Civilization*. New York: Artisan Books, 1997.

Kandinsky, W. *Concerning the Spiritual in Art and Painting in Particular 1912 (The Documents of Modern Art)*. New York: George Wittenborn, Inc., 1947.

Karlin, E.Z., "Lover's Eye Jewels—Their History and Detecting the Fakes?" *The Lux Report*, September 6, 2018.

Landau, T. *About Faces*. New York: Anchor Books, 1989.

Lee, D.H., and Anderson, A.K., "Reading What the Mind Thinks from How the Eye Sees," *Psychological Science*, April 1, 2017.

Lienhard, D.A., "Roger Sperry's Split-Brain Experiments (1959–1968)" *Embryo Project Encyclopedia* (December 12, 2017). Arizona State University, ISSN: 1940-5030. http://embryo.asu.edu/handle/10776/13035

Mendelowitz, D.M., Faber, D.L., and Wakeham, D.A. *A Guide to Drawing*, 8th ed. Cengage Learning, 2011.

Miguel, L., "Reading and Math Scores in U.S. are Falling. Why Are We Getting Dumber?" *The New American*, November 2, 2019. https://www.thenewamerican.com/culture/education/item/33915-reading-math-scores-in-u-s-are-falling-why-are-we-getting-dumber

Nicolaides, K. *The Natural Way to Draw*. Boston: Houghton Mifflin, 1941.

Rubin, P.L. *Images and Identity in Fifteenth-Century Florence*. New Haven: Yale University Press, annotated ed., 2007.

Sperry, R.W., "Hemisphere Deconnection and Unity in Conscious Awareness," *American Psychologist* 28, 1968, p. 723–33.

Stewart, J.B. "Norman Rockwell's Art, Once Sniffed At, Is Becoming Prized," *The New York Times*, May 23, 2014.

Wolf, B.J. *Multisensory Teaching of Basic Language Skills*, 3rd. ed. Baltimore: Brookes Publishing, 2011.

Young, A.W., "Faces, People, and the Brain: The 45th Sir Frederic Bartlett Lecture." *Quarterly Journal of Experimental Psychology*. Canterbury: Keynes College, University of Kent. First published January 1, 2018.

INDEX

Note: Page numbers in *italics* indicate photo captions.

left eye, representing
 darkness/moon, 79
left hemisphere. *See* brain
 hemispheres
left-eye dominance. *See also*
 eye dominance; right-eye
 dominance
 connecting with, 32–34
 emotion perception and, 33
 left-handed and, 126
 population percentages, 30, 124
 right-handed and, 125–126
 testing for, 25–26
left-handedness
 characteristics of, 124
 left-eye dominant and, 126
 meanings of, 123–124
 population percentages, 124
Lew, Jacob L., signature, 77
linear perspective, 65
Lover's Eyes, 114

male artists, painting female sitters,
 56–57
male eye miniatures, 124
Man in the Red Turban, The (van
 Eyck), 98
Manet, Édouard, *Pariesienne,
 Portrait of Madame Jules
 Guillemet, 56*
Marx Brothers, 126–127, *127*
mechanical writing, 77
Medal of Leon Battista Alberti (de'
 Pasti), *65*
Mendelowitz, Daniel M., 89
Mendes, Ana, *108*
Michelangelo, 120, 140
mirrored face images, 30–31, *31*
mixed dominance, 26, 125–127
Modigliani, Amedeo, *Head of Jeanne
 Hébuterne, 56*
movable type printing press, 77
Mulvany, Stephanie, *52*

narrowed eyes, 37–38, 43, 44. *See also*
 symmetry; widened eyes

National Assessment of Educational
 Progress (NEAP) test, *12*
nazar (evil eye), 86
negative spaces, 10, 14, 60–63, 67,
 102, 134
New Year's Eve "Eye," 80

Obama, Barack, *31*
obsidian, 97
Oldenburg, Claes, *Scissors as
 Monument, 63*
Ottoman Empire, 86

*Parisienne, Portrait of Madame Jules
 Guillemet* (Manet), *56*
Parker, Dorothy, *35*
perception of edges, 10, 14
perception of lights and shadows, 10,
 14, 60, 108
perception of relationships, 10, 14, 69
perception of spaces, 10, 14, 60–63.
 See also negative spaces
perception of the whole, 10, 14. *See
 also* the gestalt
perceptual skills, 10
peregrine falcon, *82*
personality, 90, 96, 123–128, 136
perspective. *See* linear perspective;
 proportions
Pharaoh Akhenaton, King of
 Egypt, *96*
Phoenician alphabet, 75
phonetics, 10
phonics, 10
photographic artists, 101
photographic portraits, 96–97. *See
 also* portraits; self-portraiture
Picasso, Pablo
 Gertrude Stein, 58, 73
 Self-Portrait, 54, 106
pictographs, 73
picture plane, 66
pineal gland, 82–85
Pontormo, Jacopo, *Supper at
 Emmaus, 87*
Portrait of a Man (van Eyck), *97, 98*

ABOUT THE AUTHOR

Betty Edwards is an American art teacher, lecturer, and author. She was born in San Francisco and grew up in Long Beach, California. An artist from an early age, she received a BA in art from the University of California, Los Angeles, and exhibited her paintings in Los Angeles in the 1950s and 1960s. She later earned an MA from California State University, Northridge, and a doctorate in art, education, and psychology from UCLA.

In the 1960s, as an art teacher at Venice High School in Los Angeles, Dr. Edwards first began to understand how best to teach drawing, insights that eventually became her doctoral dissertation and then the bestselling book *Drawing on the Right Side of the Brain* (first published in 1979; revised in 1989, 1999, and 2012). From 1978 until her retirement in 1991, she was a professor in art at California State University, Long Beach.

Dr. Edwards has presented lectures worldwide on drawing, creativity, and creative problem solving. Her lifelong mission has been to return art to the public school curriculum, in her passionate belief that we should be educating the "whole brains" of our children, not just focusing on STEM subjects (science, technology, engineering, and math) or teaching to standardized tests that concentrate mainly on "left brain" subjects. This misguided focus

deprives students from developing the abilities of both modes of the brain, which has been shown to enhance learning and understanding across disciplines.

For more than forty years, *Drawing on the Right Side of the Brain* has remained the preeminent book on its subject, on the shelves of artists and art lovers everywhere and used as a standard textbook in schools around the world. The book has been translated into many foreign languages, including French, Spanish, Italian, German, Portuguese, Dutch, Danish, Polish, Hungarian, Chinese, Korean, Russian, and Japanese. Dr. Edwards is also the author of *Drawing on the Artist Within*, the *Drawing on the Right Side of the Brain Workbook*, and *Color: A Course in Mastering the Art of Mixing Colors*.

Betty Edwards lives in La Jolla, California.